LISTENING

TO

OUR

ANCESTORS

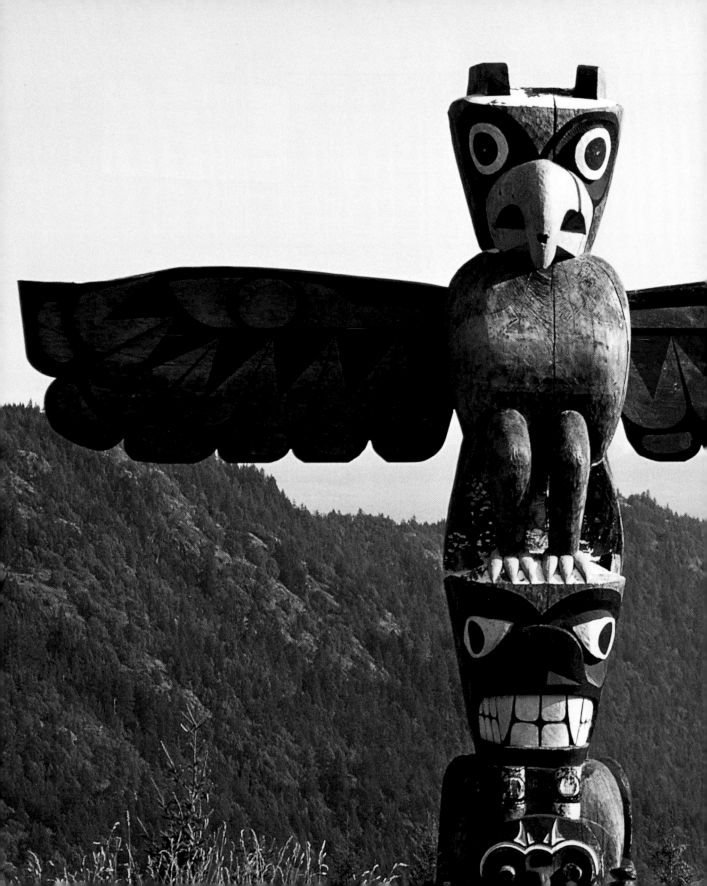

LISTENING TO OUR ANCESTORS

**THE ART OF NATIVE LIFE
ALONG THE NORTH PACIFIC COAST**

INTRODUCTION BY CHIEF ROBERT JOSEPH

**NATIONAL MUSEUM
OF THE AMERICAN INDIAN
SMITHSONIAN INSTITUTION**

IN ASSOCIATION WITH

NATIONAL GEOGRAPHIC

WASHINGTON, D.C.

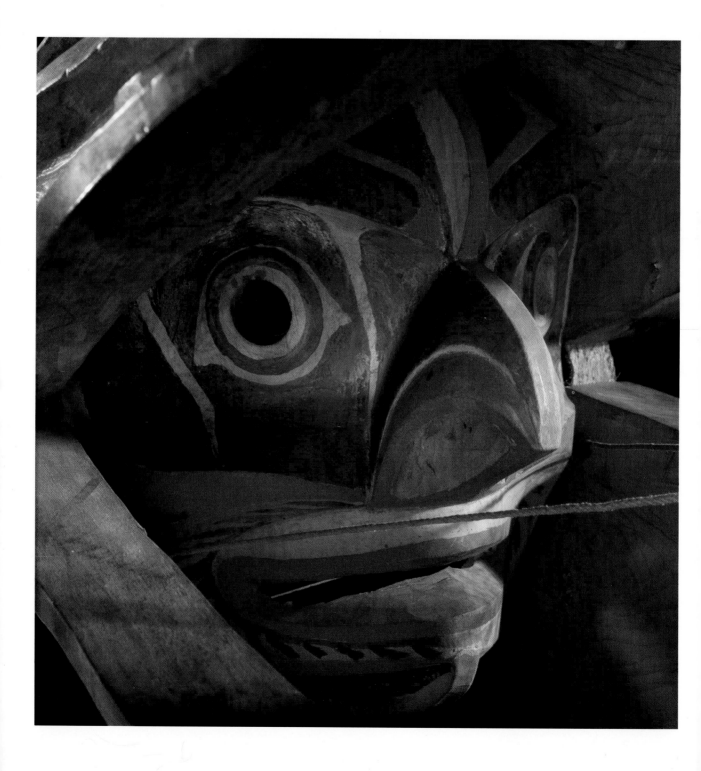

CONTENTS

HEILTSUK

TRANSFORMATION MASK

(detail)

ca. 1900

Carved and painted wood,

leather, cotton string

9/2227

Pages 2–3: Malahat Summit,

Vancouver Island,

British Columbia

FOREWORD

The art of Native life

There is something of a spiritual mathematics that comes into play, I think, in *Listening to Our Ancestors: The Art of Native Life along the North Pacific Coast*. In the not very distant past, Indians had much of their cultural lives and material goods taken from them, a devastating subtraction that we are still coming to terms with, often painfully so. But if time doesn't always heal all wounds, it certainly can change some equations. One of the primary goals of the National Museum of the American Indian is to work closely with Native communities on all our projects, so that we are giving back—through collaborating in a profound exchange of ideas and aspirations—rather than taking away. Our guiding principle, as this book and its accompanying exhibition make clear, is that Native people are the keepers of wisdom when it comes to Native cultures; it is only through indigenous knowledge and authority that we gain a true understanding of "the art of Native life."

Eleven communities accepted our invitation to work with us on *Listening to Our Ancestors*. After the exhibition in the NMAI's new museum on the National Mall closes, it will split into its eleven component parts and travel

back to the Pacific Northwest to be shown in the communities where the objects originated. These are cultures renowned for their traditions of gift-giving, and I must say that the people we have worked with have given us a gift of great value—they have transformed our relationship to the thousands of objects in our collections from the North Pacific Coast by helping us to see the deeper meanings that live within these remarkable and beautiful creations. Beyond their extraordinary aesthetic power, what distinguishes these pieces is their importance in substantiating the complex social structures of history, property, status, privileges, and responsibilities that have sustained these cultures for thousands of years.

A clue to the source of those meanings lies hidden in plain view in the title of this book. "We believe that the dead can visit this world, and that the living can visit the past," says Gitxsan writer Shirley Muldon elsewhere in these pages. That faith in the ongoing power and actual presence of our ancestors is a strongly held belief among many Indian peoples. The Native people of the North Pacific Coast, like my other Indian brothers and sisters throughout the hemisphere, are not trading in metaphors here, but in a deep conviction that those who came before are very much still with us. To listen to our ancestors is to open our spirits to knowledge not taught in school or learned in books, though I hope you will hear an echo of it here.

— *W. Richard West, Jr.*
Southern Cheyenne and member of the Cheyenne
and Arapaho Tribes of Oklahoma
Founding Director, National Museum of the American Indian

TLINGIT SHÁL (spoons) for eating whipped soapberries, from the house of Chief Shakes

ca. 1900

Carved maple

3/3619

INTRODUCTION

⬚

An elder's perspective

In this book, representatives of eleven Native nations from the North Pacific Coast of North America come together to give voice to our world views. Our tribes, known by ancient, magical names, have lived on these lands and waterways for more than 10,000 years, protected by natural barriers of ocean and mountains. In this beautiful place, our forebears crafted elaborate institutions and structures of rights and responsibilities based on kinship and history. The stories we tell are about the natural world and the spirit therein, about the living spiritual links to all things that we honor and make manifest through oral history and traditions of song, dance, ritual, and ceremony.

Aboriginal people feel that interpreting the world in our own way is imperative, or we will cease to be who we are. This idea was not lost to the chiefs who met Franz Boas in 1886 when he came among the Kwakwa̱ka'wakw to study our culture: "It is a strict law that bids us dance. It is a strict law that bids us distribute our goods among our friends and neighbors. It is a good law. Let the white man observe his law, we shall observe ours."

A scant two years earlier, the Dominion of Canada had passed a

Temperate rain forest near the Strait of Juan de Fuca, Olympic Peninsula, Washington

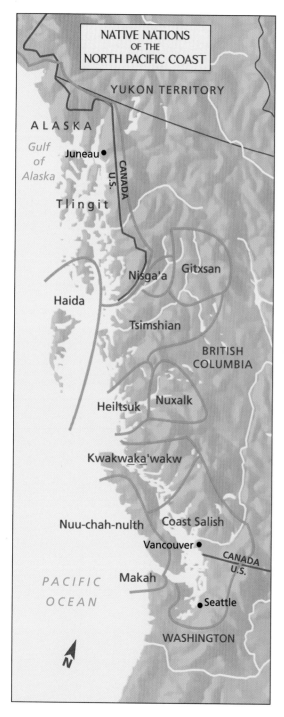

NATIVE NATIONS
OF THE
NORTH PACIFIC COAST

YUKON TERRITORY

ALASKA

Gulf
of
Alaska

Juneau

Tlingit

CANADA
U.S.

Nisga'a Gitxsan

Haida

Tsimshian

BRITISH
COLUMBIA

Heiltsuk Nuxalk

Kwakwaka'wakw

Nuu-chah-nulth Coast Salish

Vancouver

CANADA
U.S.

PACIFIC
OCEAN

Makah

Seattle

WASHINGTON

N

draconian piece of legislation banning the potlatch, our ceremonial gathering. It became a misdemeanor, punishable by fine, imprisonment, or both, to host a potlatch or take part in one in any way. The stage was set for the final assault on Northwest Coast culture by overzealous authorities, for the potlatch gives definition to our world order. It is a time of ceremony, feasting, and giving. Within its framework names are given and rights and privileges asserted; marriages are conducted, rites of passage honored, and the deceased mourned.

In 1921, Kwakwaka'wakw Chief Dan Cranmer defied the authorities by hosting the largest and most lavish potlatch recorded on the central coast to that time. The event was a showcase of extravagance and generosity to celebrate a marriage feast and conduct the business of the sacred winter ceremonials. Hosting the potlatch and taking part in it were acts of resistance in keeping with the collective will of the Kwakwaka'wakw people and chiefs.

The Royal Canadian Mounted Police arrested forty-five people who were involved in Chief Cranmer's potlatch. They were told to surrender the masks, robes, and other ceremonial regalia that symbolize our families' history and social position, or go to jail. To be charged with such crimes as speaking, dancing, and giving or receiving gifts appeared to the Kwakwaka'wakw to be an utter contravention of natural law. In the end, twenty-two proud defendants refused to bow to the will of the authorities. Twenty-one men and

women were imprisoned in Oakalla Provincial Prison for two months, while one man was jailed for six months as it was his second conviction. A deep sorrow blanketed the Kwakwaka'wakw people as the local Indian agent cruelly displayed their surrendered treasures in the parish hall at Alert Bay, charging twenty-five cents admission. Within two years their cultural inheritance began showing up in museums and private collections.

Much has gone wrong between aboriginal people and mainstream society. I have been witness to this falling out within my own lifetime. I remember attending many potlatches as a child. I was mesmerized by the great oratory of Chief Willie Seaweed and Chief T. P. Wamiss. The sun rose and set around the winter ceremonies. Dzunuḵwa and Baḵwas, the protagonists of dances, were real to me, and the sound of the wild cannibal dance sent shivers up my spine. The Thunderbird, Whale, Bear, Wolf, and all manner of living things were a part of the universe floating around in my head. It all came crashing down when I was six years old, when my grandfather, who was my legal guardian, passed away and suddenly I found myself in St. Michael's Indian Residential School.

St. Michael's in Alert Bay, the site of Boas's chastisement and of the potlatch trials, was one of many Indian boarding schools set up by church and state throughout the United States and Canada. There are some who defend the schools and their expressed goal of assimilating Indian people. For me, if the definition of assimilation is the complete destruction of culture—and it was—then there is no redeeming grace about those institutions.

At the heart of aboriginal culture are the child and family. This is

reflected in a phrase I heard in many chiefly speeches: "But for our children, what would our purpose be?" Church and government authorities recognized this and deliberately designed an education system that would destroy our heart. I arrived at St. Michael's knowing no English and was strapped severely on that first day for speaking Kwak'wala. It is not necessary to wonder what surprising turns of phrase and thought have been lost in the suppression of aboriginal languages. It is enough to realize the magnitude of love people from an oral tradition have for the language of their ancestors. It is enough to imagine the impact upon families when the children of my generation no longer shared the language of our parents and grandparents. In Canada, more than 150,000 Native children attended schools like St. Michael's, many of which were not closed until the 1980s.

Contact between Native and non-Native people didn't have to be this way. We could have shown respect for one another and our world views. Perhaps we still can. Today government, church, and aboriginal people are struggling to rectify the injustices of the past, and in particular the disregard for aboriginal title to land and resources and the dire legacy of residential schools. In Canada, legal remedies are being played out, and alternate means for resolving disputes have been designed. Apologies have been given, and healing initiatives are under way. This may well be a time of renewal and hope.

I think that is why I am so deeply moved by the creation in Washington, D.C., at the very center of U.S. power, of the National Museum of the American Indian. For it offers a place where Natives and non-Natives can

come together in reconciliation, as well as celebration, and with respect for what we have to learn from each other. In that spirit, the museum has proposed that the objects chosen for this project should travel back to the communities where they were made, to be on exhibit there before returning to the museum's collections.

As I grow older and enter the final phase of my life, I see things from an elder's perspective. I see the brilliance of the society our ancestors created. I see how they fulfilled the need for balance, harmony, and resolution in the world. I see it in our dances. I hear it in our songs. We honor it in our ceremonies and rituals. Is it any wonder then that the anti-potlatch law and all the other attempts to do away with aboriginal people were doomed to fail?

I am grateful that, in the decades since I left St. Michael's, I have been able to embrace much of my Kwakwaka'wakw heritage. Today I am one of the speakers in our ceremonial houses. In Northwest Coast cultures, we must never speak highly of ourselves, but should leave that talk to a representative. So at the beginning of each potlatch, I speak for the host and formally welcome his guests. I describe to the gathering the events that will unfold. I speak of the glorious history of the host chief and of his great wealth and stature.

My part in this wonderful, creative project was very modest. In the tradition of the potlatch speaker, however, I am honored to say these few words of introduction and praise for the people and the rich cultural legacies represented in this book.

— *Chief Robert Joseph*

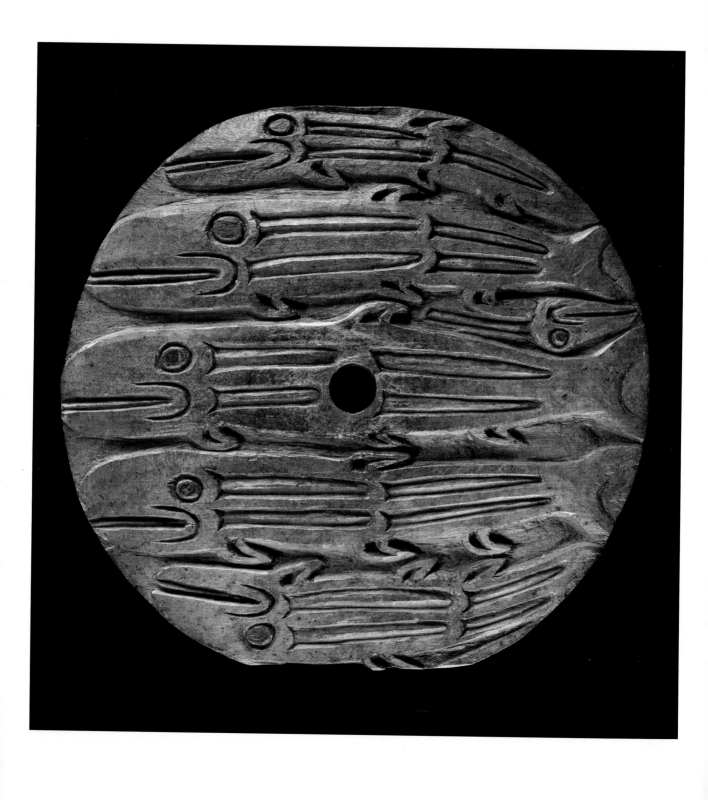

COAST SALISH

The beauty of everyday things

Coast Salish culture encompasses some thirty communities on Puget Sound and along the southern shores of Vancouver Island and the adjacent mainland of British Columbia. Linguists point to the dozen related but distinct languages spoken in our villages as evidence of our long history here. We acknowledge this wealth of languages when we tell how the Creator walked around the world, distributing languages from a large cedar basket. When he got to our lands, he turned the basket over and spilled out all the languages he had left.

The Coast Salish people were part of a trading economy that reached from southeastern Alaska to northern California, and east across the mountains to Montana. Contact with traders from Britain and France, and from other Native tribes, is reflected in the Chinook trading jargon, whose dialects were the shared language of the coast in the 1800s and early 1900s. The influx of non-Natives into the region during the gold rushes of the second half of the nineteenth century brought great changes to our way of life. In the past 150 years, we have suffered epidemics of smallpox and other illnesses introduced into our population. We have been moved to reservations and reserves

COWICHAN SPINDLE WHORL

with design suggesting

a school of salmon

Early to mid-19th c.

15/8959

on small parts of our traditional lands. We have seen the establishment of boarding schools that taught us English, but did not allow us to use our own languages or practice weaving, fishing, hunting, and carving.

Here, I would like to give you a small understanding of the daily life of our people before these changes came and of the creativity and skills that have helped us survive for thousands of years.

The spindle whorl shown on the first page of this chapter is an appropriate place to begin. It is carved of wood from the forest that provided us with everything from clothing to our means of transportation. The salmon of its decoration represent our most important source of food. Its elegant design shows that our ancestors valued beautiful and well-made things.

LIFE ON THE WATER Coast Salish canoes were made in many different styles and sizes depending on their uses. Not everyone carved. There were, and are, canoe-carving specialists; when a family needed a new canoe, it would commission a specialist to make it. The felling of a cedar was planned to take place at a time when the tribe could get the most efficient use of the tree and not waste any part of it. Depending on how the wood split, a skilled carver could use one large log to make two large canoes or four small canoes. The carver began by shaping the outside of the canoe. Before turning his work over to hollow out the interior, he would drill small holes in various places along the hull and fill them with painted cedar dowels cut to

specific lengths. The dowels were covered with pitch to ensure that the hull remained water-tight. He hollowed out a rough interior with fire, then continued hollowing with an adze. When his carving exposed the end of a painted dowel, he knew that the hull at that point was the proper thickness.

Canoes were carved to master the open ocean, as well as the waters of Puget Sound and the straits, as people traveled up and down the coast fishing, trading, and hunting. Coast Salish river canoes were renowned for their ability to navigate narrow streams and very shallow water. They were also extraordinarily stable. While a paddler or poler sat or stood in the stern of the canoe, a fisherman could stand in the bow and lean out over the water to spear fish. Much larger traveling canoes could carry as many as one hundred people. They became known by non-Natives as "war canoes," although true war canoes were painted gray or white, not black or brown, as light-colored canoes are very hard to see from shore. Smaller family canoes were used for visiting or to travel to the family's fishing camp.

In the spring, when the salmon returned to the rivers, families moved to their fishing camps. Salmon were smoked and dried for winter and to trade with inland tribes.

DUWAMISH DUGOUT CANOE,

1880–1910

Cedar and metal

9/7294

Following pages: Howe Sound, near the Coast Salish village of Squamish, British Columbia

Smelt, herring, trout, halibut, cod, and other fish were also harvested, but salmon was, and is, the prize fish. I heard an elder once say, "The salmon is to us on the coast what the buffalo is to the people of the plains. We survive on the salmon." Our fishing rights, though guaranteed by treaty, have not always been honored, and we have had to fight for them. In 1974 the courts finally affirmed the right of Natives in coastal Washington to fish our usual and accustomed grounds. We exercise this right with great respect for the salmon and for our ancestors who taught us how to prepare them. Today many Coast Salish communities, like other Native groups in the Northwest, have established salmon hatcheries on our rivers and streams, to the benefit of everyone who fishes these waters.

Several Coast Salish communities on the U. S. side of the border have decided in recent years to open casinos. The Clearwater Casino of my own Suquamish Tribe has provided jobs for our people and is enabling us to buy back reservation lands now held in private hands. In the past Coast Salish men gambled at social gatherings, for fun as well as in the hope of winning foodstuffs, blankets, baskets, canoes, and even slaves. The beaver tooth game, played by children and women, stressed counting and memory skills, though today many women are also very good at the men's games. Songs and gaming pieces belonged to families and were passed down from generation to generation.

A COAST SALISH HOME In the old days, a family of grandparents, parents, aunts and uncles, brothers, sisters, and cousins lived together in a large

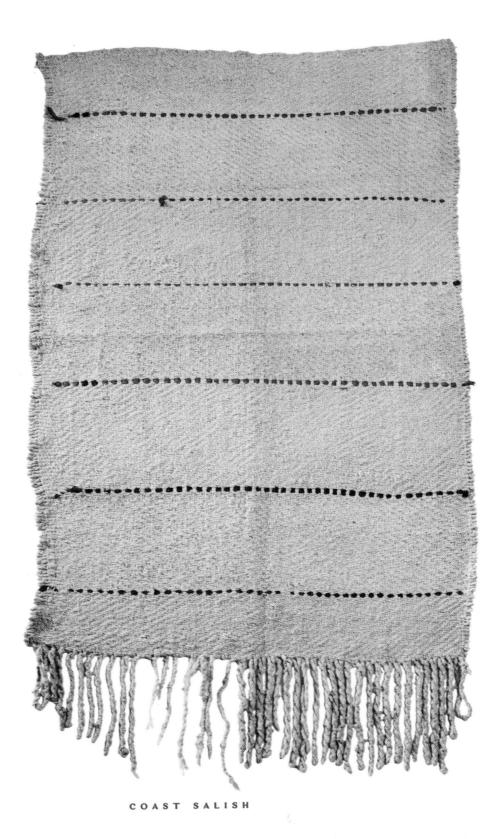

COAST SALISH

cedar house. Grandparents cared for the young children and taught them weaving and carving. They taught ways to be very quiet in case there were ever enemies in the village. Mothers taught the older girls where to gather plants for food and basketmaking, how to spin wool and dry and split basketry materials, how to weave baskets, and how to prepare all types of foods. Fathers taught hunting, carving, and how to defend the village. Both taught respect for elders and for the earth that offers its bounty for our survival.

TWANA OR SKOKOMISH BASKET

with four winds motifs

ca. 1900

Red cedar root, wild

cherry bark, and

nettle root

5/7926

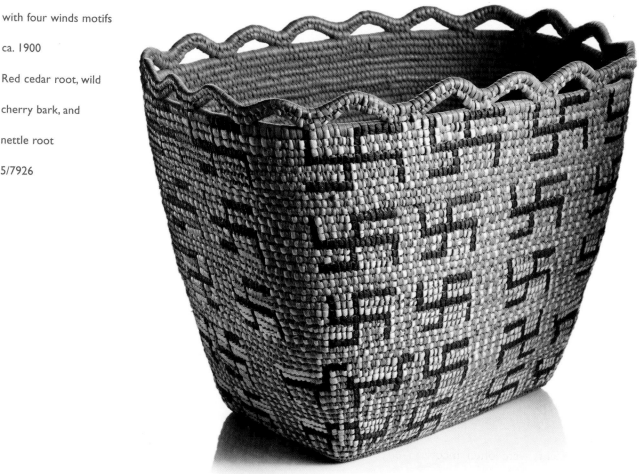

Spring and summer were times for the hard work of gathering everything needed to survive the winter. Fall was time for drying food and storing it. Winter was time for storytelling and teaching about our history and genealogy and the creations of our world. Today we struggle to find time for the teachings of our elders. Carving was also done mostly in winter, and canoes and nets were repaired. Carvings were made not as art, but to be used, and each item had a purpose. It was easy to tell who the owner of a piece was by his or her family crest. Now carving and woodworking are often done to earn money. Even so, many carvers today were taught by their grandfathers or other respected elders, and these carvers are still commissioned to make things to be used in traditional ways. In many cases this work is not paid for with money but, as it was 150 years ago, with food, furs, good wood for carvings, or metal to make carving tools.

Salish weavers are renowned, especially for their twill work. The sleeping blanket shown on page 21 was made by a weaver or weavers on the Fraser River, home to the most accomplished Salish weavers. More elaborate Chilkat or Raven's Tail blankets were often acquired in trade or through marriage. Weavers often set up their upright looms outdoors, to make use of the daylight. At night, they covered their work with cattail mats. For yarn, women gathered and spun wool from mountain sheep and mountain goats. Different whorls could be used with a single spindle to spin different weights of yarn. Yellow and red cedar bark and other plant fibers, like the cotton of the fireweed plant, were often incorporated into yarn to give weavings

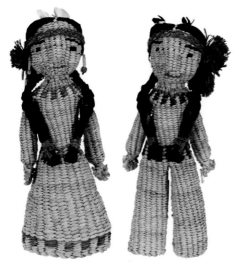

TULALIP DOLLS

Made by Agnes James

ca. 1965

Braided and woven cattail fiber

adorned with feathers, pigment,

plastic beads, wooden beads,

sequins, and thread

25/5309 & 25/5308

Department of the Interior, Indian

Arts and Crafts Board, at the

National Museum of the American

Indian, Smithsonian Institution

strength or color. Weavers sometimes worked their own hair or a family member's hair into special weavings. At one time the Salish, Makah, and other Northwest groups kept a breed of small woolly dogs whose fine fur could be gathered or sheared for weaving. These dogs appear in our stories, and the explorer George Vancouver mentioned them in the journal of his voyage through Puget Sound in the early 1790s. These dogs may have died out through inbreeding or by breeding with ship's dogs. There are some examples of dog-hair blankets in museum collections; however, to my knowledge no tribe or band still has any of these blankets.

Weaving designs and styles were family-owned and passed down from mother to daughter or grandmother to granddaughter. There are also Coast Salish men who are well-respected for their weaving. If a boy is an only child, and the women in his family wish to preserve their knowledge of weaving for the future, they will teach him. These men pass the knowledge on to the next generation, teaching their own daughters and sons.

Basketry designs are often similar to those used in weaving. They may record an incident in history or tell where a piece was made. The Skokomish dog design is visible in the lower corners of the basket shown on page 22, all but lost below the four winds motifs. I'd like to explain why we chose to publish this basket, which I regret will disturb many people. When I showed this basket to our elders, they felt it was important to try to reclaim this ancient symbol of the four winds, or at least to explain that it was not originally a symbol of evil, but of the strength of the wind. It was expropriated and

perverted by Adolf Hitler, who reversed it for the Nazi Party flag. After the Second World War, our people stopped using it in their designs.

This basket was made by a very skilled weaver, using wild cherry bark, cedar root, and nettle root. It may have been an heirloom. Certainly it shows no evidence of having been used to hold things. Basketry techniques are used to make hats and mats, as well as containers of every description. Dolls like the small cattail-fiber dolls on the facing page are woven beginning at the top of the head and working downward. These dolls, made by Agnes James, demonstrate that basketry skills are still alive among the Coast Salish. The doll on the left, in particular, represents a Salish girl looking very proper in traditional dress.

Because Coast Salish families traveled during the fishing and gathering times, we did not need a collection of household dishes. Traditionally, as children grew in responsibility, each would be given a carved wooden spoon and a cedar rope belt to keep it on. At mealtimes members of the family would wash their faces, hands, and spoons and eat from shared dishes. Everything used in our daily lives was designed to be mobile and not to be wasteful. Spoons made of mountain goat horn or mountain sheep horn were used during ceremonies and celebrations. The women of a family would carry carved and painted feast dishes to the celebration.

Because of the sacredness of these events, I cannot describe them, although in other chapters of this book communities have given permission for their ceremonies to be explained. Each tribe, band, or nation has its own belief system, and it is not exactly the same as that of neighboring peoples.

— *Marilyn Jones*

FEAST SPOONS

Late 19th to early 20th c.

Horn

15/6121

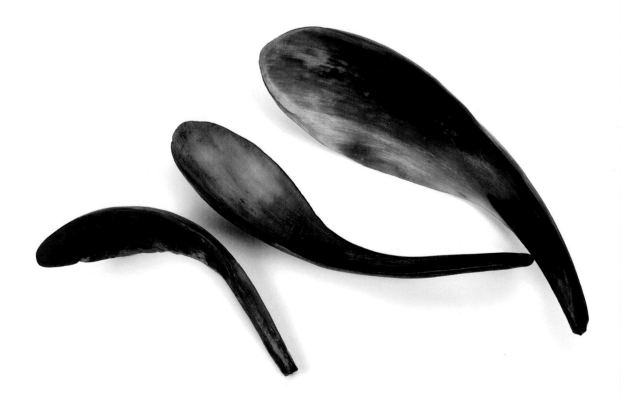

"Every part of this country is sacred."

Your religion was written on tablets of stone by the iron finger of an angry God, lest you might forget it. The Red Man could never remember nor comprehend it.

Our religion is the traditions of our ancestors—the dreams of our old men, given to them by the Great Spirit, and the visions of our Sachems, and is written in the hearts of our people.

Your dead cease to love you and the homes of their nativity as soon as they pass the portals of the tomb. They wander far away beyond the stars, are soon forgotten and never return.

Our dead never forget the beautiful world that gave them being. They still love its winding rivers, its great mountains and its sequestered vales, and they ever yearn in tenderest affection over the lonely-hearted living, and often return to visit and comfort them. . . .

Every part of this country is sacred to my people. Every hillside, every valley, every plain and grove has been hallowed by some fond memory or some sad experience of my tribe.

Even the rocks, which seem to lie dumb as they swelter in the sun along the silent shore in solemn grandeur, thrill with memories of past events connected with the fate of my people, the very dust under your feet responds more lovingly to our footsteps than to yours, because it is the ashes of our ancestors, and our bare feet are conscious of the sympathetic touch, for the soil is rich with the life of our kindred.

— Chief Seattle (Suquamish)
from his speech to the territorial governor, 1854

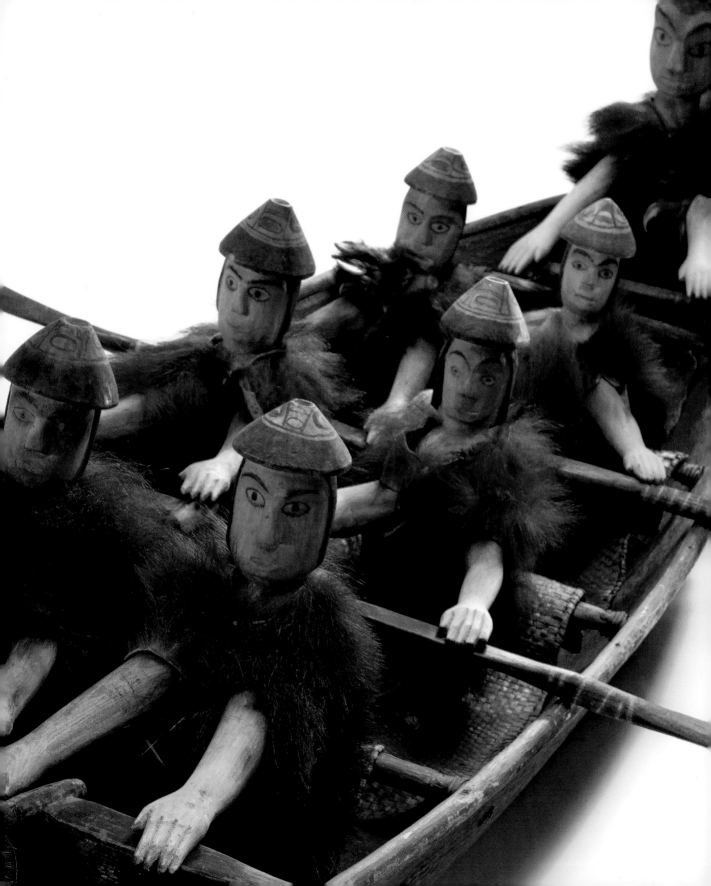

MAKAH

All that our past has generously bestowed

We are qʷidičča?a·tx̌, people who live near rocky crags, within earshot of a multitude of sea gulls. Our elders say we have lived in this place since the beginning of time.

We are qʷidičča?a·tx̌, knowledgeable people with respect for ceremony, gracious hosts, people who honor invitations, generous with food. We are rich by measure of how much we give, not by what we gain. The name Makah, given to us by our S'Klallam neighbors, refers to the generosity of our feasts. We are celebrators of the great events in our lives, supporters of other tribal members, their families, their elders, and their children.

We are resourceful in our endeavors, technologically apt, respectful of our natural world. We seek to be humble before the One Above, with whom we unite in prayer and who gives us each new daybreak.

We have lived in five ancient communities—?use?ił (Ozette), čuyas (Sooes), wa?ač (Waatch), di'ya (Deah, now Neah Bay), and bi?id?a (Bahaada)—and many summer encampments. We are marine mammal

MAKAH MODEL CANOE

AND FIGURES (detail)

Made by Young Doctor

(1850–1933), ca. 1900

Carved and painted wood,

black bear skin, cedar bark

6/8874

hunters, using vast numbers and various species of whales and seals, sea lions, otters, and porpoise. We are fishermen, from the shallows of the bays to the deep ocean floor, of species from herring and smelt to giant halibut and salmon. We are gatherers of all manner of seafood, shells, and plants. We are the ones who prosper from the waters that surround us and who know these places intimately. We have profound respect for the life of this place that sustains us. Our reverence for the water has compelled us to become expert canoe carvers and ocean navigators. We have become masters of the technologies associated with working wood, antler, bone, shell, root, bark, reeds, and grasses.

We have sustained ourselves in this place for thousands of years. We are diverse in our occupations, fulfilling the needs of the tribe as a whole. We are known by our legal names, our Native ancestral names, and the histories of our lives. We are qʷidiččaʔátx̌.

When the whites came here to civilize us, to teach us how to farm, they gave us pitchforks. The weather here is not good for farming: too much rain. Our men decided to take the tines of the pitchforks and bend them into fishhooks.

—Hildred Ides

We are qʷidiččaʔátx̌. Our traditional lands range along the Pacific coast of the Olympic Peninsula from Cape Johnson in the south to the fishing banks off Vancouver Island in the north, and east along the Strait of Juan de Fuca

to Freshwater Bay. Our ancestors had the vastness of the open ocean in front of them, and they weren't afraid of it. From Cape Flattery, the westernmost edge of the continent, you can capture a glimpse of the waterways our people used. They took their canoes into the fog, out of sight of land, and navigating without a compass, they hunted whales and other marine mammals with harpoons made of yew and tipped with shell blades.

Our cultural heritage surrounding whales and whaling is rich. Whale hunting required more than courage. It demanded strength and remarkable technical knowledge: the use of line and floats, the use of different woods for canoes and harpoon shafts, the behavior of whales, how to read the tides by the sea grass, kelp, and other indicators.

Daybreak they sized the whale up, and the whale has got to be approached not with the sun, because he sees your shadow, . . . You approached by watching its wake. When he's going to surface, the wake gets closer together . . . and the man in the bow, he motions his paddlers. Kind of, "Paddle fast," and that signal for going fast was overhand. Or if you know he's going to come up just in target range, the motion will be underhand. You hold the same speed paddling.

—*Harold Ides*

MAKAH

SALMON TROLLING HOOK

ca. 1910

Baleen shank and bone barb,

bound with plant fiber

15/6961

Whalers went off by themselves to pray, fast, and bathe ceremonially to prepare spiritually for the hunt. Each man prepared in his own solitary place, followed his own ritual, and sought his own power. The members of the whaling crew also prayed together. Whalers' families took part in spiritual observance, as well. During the hunt, until a whaler's canoe returned, his wife didn't eat, lest the whale dive. While her husband's canoe was at sea, she lay still at home so that the whale would be calm.

Together with the Nuu-chah-nulth, we are the only Northwest Coast people who hunted whales. Before the arrival of non-Native ships, we defended our fishing and hunting grounds from neighboring tribes whenever necessary. In time, the Spanish, Russians, British, and Americans hunted and fished these waters.

In the Treaty of Neah Bay, signed by the Makah and the United States in 1855, our government secured and protected for future generations "the right of taking fish and of whaling or sealing at usual and accustomed grounds and stations." Our ancestors preserved this right for our people in perpetuity.

Whales are big, you know. I give credit to our Native people. They were generous. They want to help one another. Whatever you got, you . . . share with your people.

—*Tom Parker*

By the 1920s, however, commercial whaling had so reduced the whale population that it could no longer support our tradition. By the 1950s, even our treaty-secured right to fish was being challenged. Faced with a growing non-Native fishing industry and declining stocks of salmon, Washington State attempted to restrict Native (but not non-Native) fishing. Among other arguments, the state claimed that fishing nets were a European invention, and should not, under our treaty, be available for use by Native fishermen.

We had, however, extraordinary evidence to support our position. In 1947 archaeologists surveying the Olympic coastline noted a thick shell midden at Ozette, the southernmost Makah village. Before Contact and the epidemics that ravaged our population, each of the Makah villages was home to as many as 500 people. These villages were made up of several longhouses built of cedar planks and measuring some thirty feet wide and seventy feet long. Several generations of a house, or extended family, shared a massive building. The last permanent residents left Ozette in 1917, as Neah Bay, the site of our school, became our principal community. Then, in 1969, a section of the bank at Ozette collapsed toward the ocean, exposing an old longhouse and its contents. That winter, the Makah Tribal Council passed a resolution stating the tribe's intention to build a museum to care for the objects found at the site.

WAR CLUB

Early to mid-19th c.

Carved and painted whalebone

6/35

In Ozette, we have inherited an extraordinary time capsule. Archaeological research has established that the site and the area around it were inhabited for approximately 2,000 years. Sometime between A.D. 1500 and 1700, a landslide buried at least four cedar longhouses in mud and clay. Among the more than 50,000 artifacts recovered from the site are basketry, clothes, hats, sleeping mats, and cradles; bentwood boxes and fishhooks; and stone and iron tools and copper ornaments. We have found personal things—a folded pouch of fishhooks and the bits of bone and stone used to make them, a sewing kit in a small basket. Even delicate plant fibers were preserved by the waterlogged clay.

We used a piece of fishing net excavated from Ozette as evidence in court to preserve our right to fish with nets. Our elders said we made nets, and there it was. No one could argue with it.

If she wanted to be skillful in basketweaving or making blankets, she prayed about it—prayed over the things she's going to use before she uses them.

—Helen Peterson

The inventiveness of our ancestors is a source of great pride. Our people's woodworking skills were ingenious. We created both highly technical utilitarian objects and wonderful decorative pieces without chain saws, scroll saws, jigs, or Dremels. We worked objects with bone, tooth, wood, antler, shell, and stone—combined with great creativity.

BREASTPLATE

ca. 1900

Dentalium shell and beads

10/147

Many members of our generation have worked at Ozette, or visited the site on field trips from school, and our experiences there help fuel our determination to preserve our culture. Several of the unique items we have found at Ozette were still being made and used within living memory. Our elders described how to play with the beaver-tooth dice and game paddles. Objects reminded them of the oral histories they heard as children—family genealogies and stories of whaling and sealing. They recalled the old words for things. Recently we reorganized the objects in our storage collections according to their qʷidič č aʔaʼt names, in an attempt to see them as the people who made and used them did. Originally, we shelved bowls and wooden boxes together, in a section for containers, but the suffix for a container is sac, and the word for a box is haẋ°i'dukš. When we asked one of the elders, she explained that although the old people knew that boxes were containers, and used them as containers, "container" was not the first thing that came to mind when they thought of boxes. By classifying our collection in this way, we understand a little more about how the people of Ozette saw the world.

In 1995, after the National Marine Fisheries Service determined that the population of gray whales had recovered sufficiently to remove them from the endangered species list, we decided to return to hunting whales. Our

MODEL CANOE WITH FIGURES

Made by Young Doctor

(1850–1933), ca. 1900

6/8874

relationship with the whale is very old. Even the most ancient deposits at Ozette hold humpback and gray whale bones and barbs from harpoons. We petitioned the U.S. government to go before the International Whaling Commission to request an aboriginal whaling quota. The commission authorized us to hunt up to five whales a year, with the understanding that the hunts would not be commercial ventures, but rather cultural and spiritual journeys; that whale meat could be consumed locally only by members and guests of the tribe; that whalebones would be catalogued and provided to Makah artists to revive the art of whalebone carving; and that hunters would be chosen from the twenty-three lineages of Makah families.

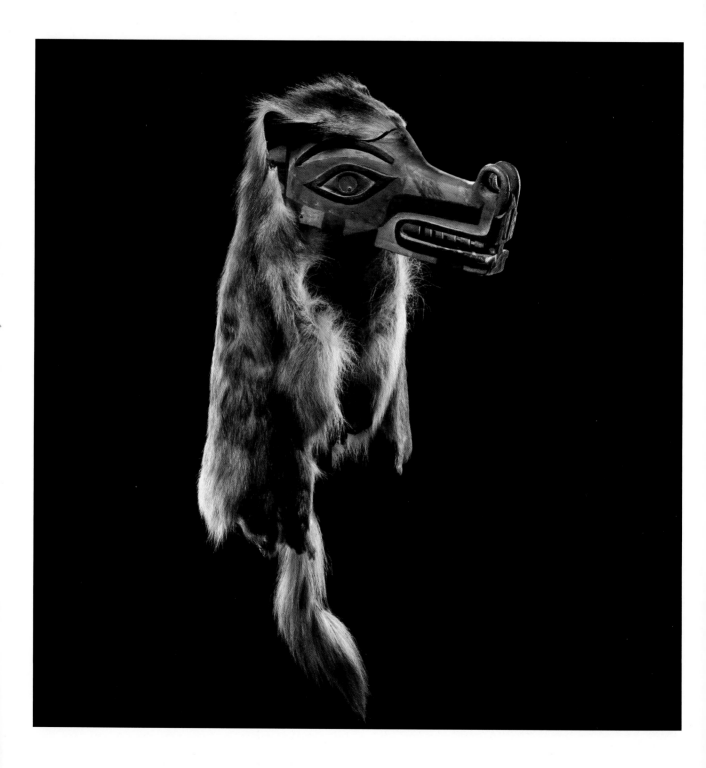

LISTENING TO OUR ANCESTORS

In May 1999, more than seventy years after the last Makah whale hunt, Makah men in a wooden canoe brought a whale home to feed our people. That morning, as the news of the successful hunt spread, we assembled on the beach at Neah Bay to welcome the whale to the community as our ancestors did. Canoes came from surrounding villages to greet the honored guest who would in turn provide for our people meat, blubber, oil, bone, baleen, and sinew. As the whale was brought to shore, people ran into the water to touch her smooth skin. Children looked on in amazement at her size. We then prayed over the whale and the whalers. Prayers were offered to honor the spirit of the whale and thank her for giving her life to sustain the lives of the Makah. After proper respect was paid, the whalers began carving and distributing the meat and blubber. Many of us tasted for the first time foods that had been staples for our ancestors for thousands of years. The whale was butchered through the night, and the Makah Tribe hosted one of the largest celebrations in our history. People came from all over the world to celebrate our return to whaling.

More than any other act, the whale hunt represents our physical and spiritual preparedness and the wealth of our culture. We have lived through the onslaughts of European-American epidemics against which we had no immunities; through the domination of Indian agents; through government boarding schools, extreme prejudice, the forced speaking of English, and intense psychological abuse. Yet we are here. We are proud of our heritage, proud of who we are, where we come from, where we live.

MASK REPRESENTING A WOLF

ca. 1890

Carved and painted wood, fur

5/5049

We are all that our past has generously bestowed upon us in knowledge, respect, beliefs, customs, and values. We are what our living culture dictates and what the present adds through the passage and changes of time. We are what we demonstrate through the way we live our lives. For generations to come we will continue to sustain our culture and our language. We will take care of and protect our ways, our people, our land, our waterways, and our resources. Our future will be determined by what our culture asks us to embed in the strong hearts and minds of our children, who will in turn carry the teachings of our ancestors to generations after them.

— *Janine Bowechop, Meredith Parker,*
Maria Pascua, and Rebekah Monette

RATTLE REPRESENTING

A GROUSE

19th c.

Carved wood, metal

9/9907

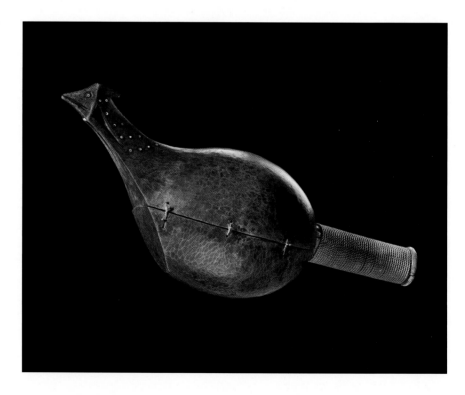

Following pages: Humpback whales feeding in their summer waters along the North Pacific Coast

Song of the seven daylights

My great-great-grandfather never did come back with nothing. He always had a whale. One time when they went out, he speared a whale and got his leg caught in the rope—the sinew rope that they threw out. When the whale dove under, he went right out with the whale because he couldn't get his ankle all untied. The whale took him around in the ocean for quite a while. When the men in the canoe finally let the rope go, they thought that he had drowned, but they waited around for a while anyway. After he went under, he found enough strength within himself to untie himself. . . . He got all untied. When he came up, the guys saw him come up—they saw blood all around him—he had a terrific nose-bleed from surfacing too fast. They couldn't believe that he was alive! He lived through the whole thing!

He said to them, "I got a song when I went under. When I went under I saw seven daylights"—in other words he saw seven changes in the light as he was dragged under, farther and farther down. So, this is the song that he received after he came up from under the water. That's also where he got his name *dashúk* (strong), because there hasn't been anybody that they know of that went down under as far as a whale could drag him and then came back up again. So, when he came up, he got this song, which my mother used, and I now use. . . .

I went down as far as any human possibly can,
To where the earth meets with the water,
From daylight to dark,
And came back up again.

— *Helma Swan (Makah)*

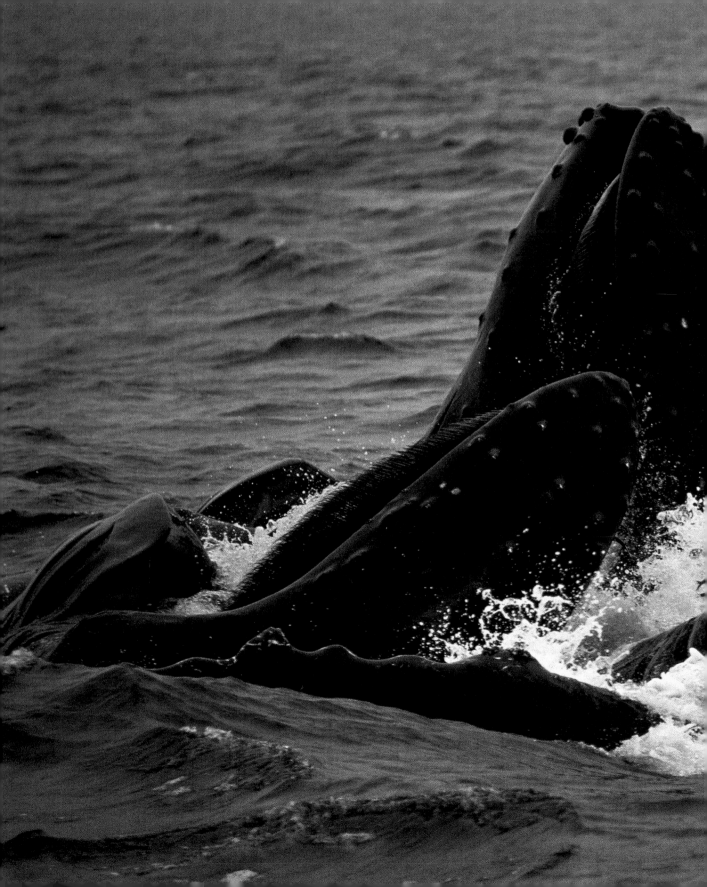

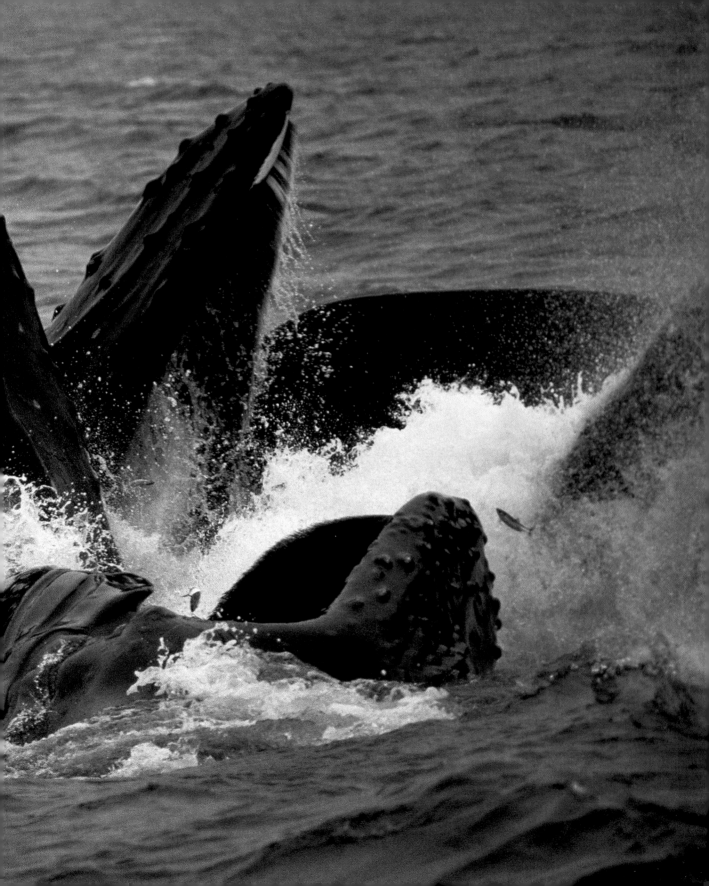

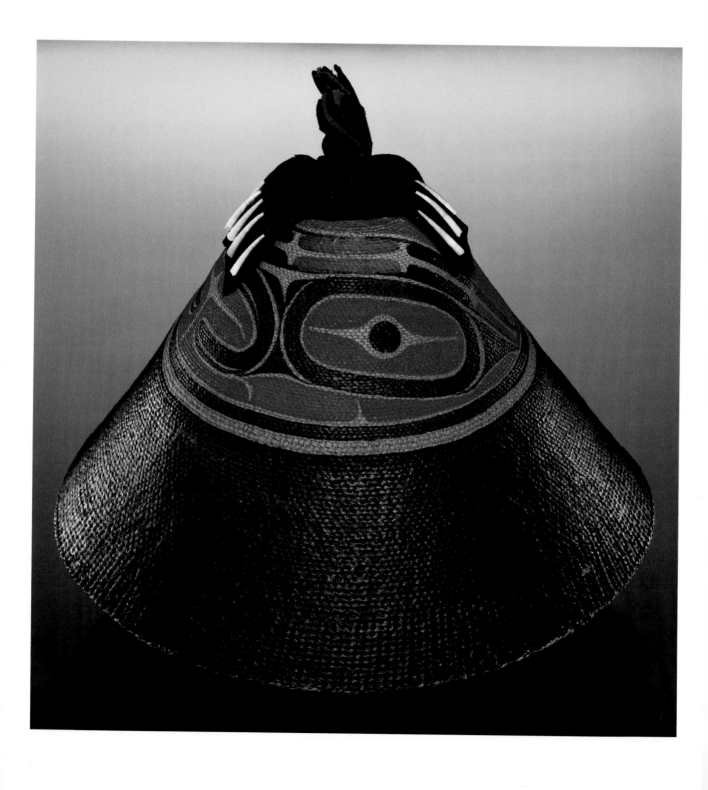

N U U - C H A H - N U L T H

◨

A nation always praying

We Nuuchaanulthiat-h see the universe as composed of four great realms. The sea world, our front yard, is overseen by Hilthsuu-is Ha'wilth (literally Undersea Great Spirit Chief). The land and mountain world, our immediate home, is overseen by Ha'wii-im (Great Spirit Chief of the Land). The sky world, watched closely for signs of impending weather, is overseen by Yaalthapii Ha'wilth (Way Up in the Sky Great Spirit Chief). The spirit world is overseen by Ha'wilthsuu-is (Great Spirit Chief Beyond the Horizon).

The seas for miles of shoreline and all of the land on the western side of our Vancouver Island home, from Point No Point in the south to Brooks Peninsula in the north, is Nuu-chah-nulth haahuulthii (territory). True maritime people, we owe much to Hilthsuu-is Ha'wilth: seaweed, seals, five species of salmon, halibut, herring, numerous bottom fishes and shellfishes, calm seas to travel on—the foundation for a rich way of life.

To Ha'wii-im, we owe thanks for elk, deer, bear, fur-bearing animals, various woods for housing and transportation needs, woods for beautiful eating implements, yet other woods for diverse tools and weapons, and a limitless

HAT OF A HIGH-STATUS WOMAN

n.d.

Woven, painted cedar bark,

trade cloth, dentalium shell

8608

MOOYAPETLAM

(four-sided screen)

19th c.

Painted wood

14/7397

variety of medicines. Yaalthapii Ha'wilth provides us with edible duck, grouse, stars to navigate by at night, the moon to signal sea tide cycles, the sun to ripen berries, and rain to swell our rivers enough for rich, oily salmon to ascend to their spawning grounds. We acknowledge Ha'wilthsuu-is for our dreams, visions, songs, and all the spiritual gifts that give our lives pleasure and deep meaning. Our traditions teach us that the generous man-

ner in which our four Great Spirit Chiefs provide everything we need to enjoy a good, rich life is the model for our earthly ha'wiih (chiefs).

To continue this good life, we as kuu-as (real living human beings) must follow a disciplined schedule and observe our sacred practices governed by

lunar and seasonal cycles. We must bathe ritually, pray, and fast. We must handle physical and spiritual resources with respect. All our wealth for display—our status-validating songs, dances, and masks—is derived from individual contacts with our late ancestors or other ch'ihaa (spirit beings), messengers of the four Great Spirit Chiefs. We must share with our relatives, and we must offer thanks for the generosity of the four Great Spirit Chiefs.

Throughout the yearly cycle of ceremonies and rituals, we acknowledge our four Great Spirit Chiefs in many ways. When we feast and potlatch, we sing ha'ukshitlyak (feast songs) to express our thanks for the food we are about to consume. Not only the host family or tribe but also others, some-

times many others, sing their particular feast songs. Getting up to sing or dance these feast songs is a matter of communal pride, much like singing a national anthem. Of course, it is understood that we are thanking the appropriate deity for specific foodstuffs: Hilthsuu–is Ha'wilth for all the various sea foods; Ha'wii–im for various land animals and berries; Yaalthapii Ha'wilth for ducks; Ha'wilthsuu–is for whale meat, blubber, and oil.

We are taught to go outside immediately upon waking in the morning. To stay in bed would be to show that we are not ready to receive the rewards of a disciplined life. We give thanks for seeing another day, and for all that is good and right in our lives. On behalf of our families and ourselves, we ask humbly for long life, happiness, the wisdom to keep on learning. We also ask for strength and determination. Hunters pray for success in the chase. Berry-pickers pray that a rich harvest will greet them on our mountainsides. Fishermen pray for a bountiful catch to feed their families. Students pray for success in their studies.

Naturally, everyone planning to host a feast or potlatch prays for the success of these grand events. When taking on an important task, or facing a

particularly tough problem, we accompany our daily prayers with ritual bathing, most often high in the mountains, as close as possible to the snow. During these ritual prayers, which we call uusimch, we rub our bodies vigorously with herbs and greens. Each of our families has its own uuyii, or medicines, for this purpose—certain grasses, rare flowers, and branches of red cedar, hemlock, spruce, yew wood, and siiwiipt (ocean spray).

Our beliefs and practices were often attacked in the past by Christian missionaries, teachers, government agents, and other overly zealous people. Now, however, there is a steadily growing interest among our young people in our traditional spirituality. In a prevailing climate of pan-Indianism, our young people want what belongs to them by inheritance. They seek the truth and practices of their great-grandfathers and great-grandmothers. Often, they are told, "That's all gone now." Or, "Our beliefs are exactly the same as everyone else's. Just go to church." Yet there are also knowledgeable people in our communities willing to pass on our sacred traditions.

We believe that each human being has a thli'makstii (life force, spirit, or soul), and that we must respect the thli'makstii in all others. When a family is blessed with the birth of a new member, we gather, share a feast, and pass the baby around. This feast is called an Aa-aastimxwa. We sing songs to make the baby precious. Often, these songs take the form of lullabies. Usually the newborn is given a baby name—from his father's side, for a boy; from her mother's side, for a girl. Sometimes the newborn also receives a song or other ceremonial privilege as well. We greet babies as though we have

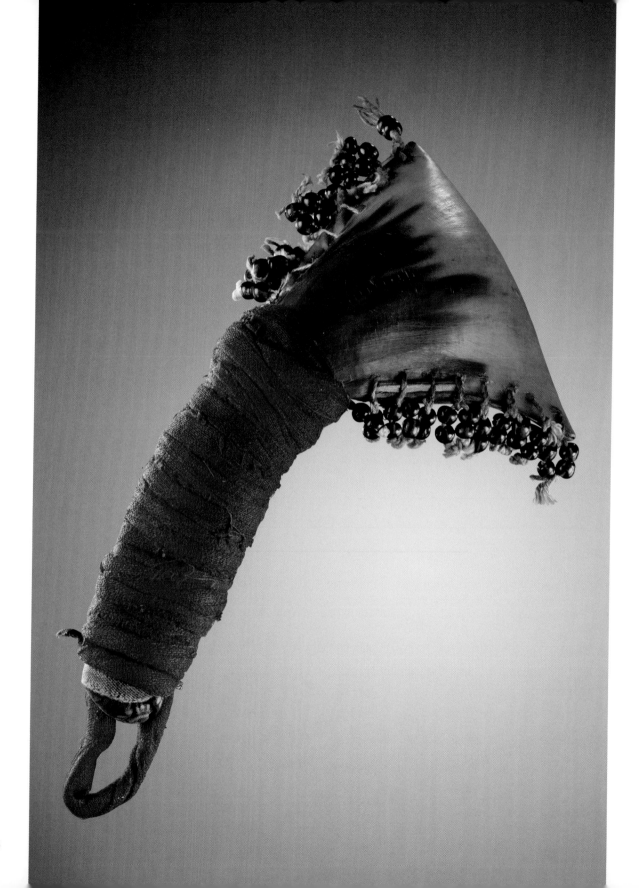

always known them and speak good words of encouragement to them. When the baby's umbilical cord falls off, an Emint'uultha (Bellybutton Feast) may be held. This provides another occasion to gather and celebrate. Usually, the food at these events is kept simple. Sometimes only tea and desserts are served. Everyone's attention is kept on the baby. When a child is accidentally hurt or suffers a life-threatening sickness, the parents may invite relatives and friends to their home to feast and brush the child off, cleansing the child spiritually of hurtful experiences and signaling that he or she is important and precious to the family and community. This type of cleansing feast is called a Yaxmalthit.

Many life-altering milestones are acknowledged. Any time a family member accumulates a surplus of fish, meat, cash, or any other form of wealth, and any time a family feels an occasion warrants it, we will feed the people and distribute our excess wealth. Often on these occasions a family member receives a traditional name formerly held by one of the ancestors. Every time we host such a do, our family's prestige grows in the community and among surrounding communities. The number of family treasures and heirlooms a family shows, the elaborateness and antiquity of the ceremonies observed, the dignity and distinctness of the ceremonial privileges displayed, even the goods and cash distributed, as well as the general atmosphere of warmth and hospitality—all affect the success of a feast or potlatch. Everyone wishes to please guests and to have it said that the family "held their name up." The reputations and prestige of our ha'wiih and other dignitaries also grow in proportion to their generosity and involvement in these events.

HARPOONER'S RATTLE

n.d

Horn, glass trade beads,

cloth wrapping

5/4198

UU-UUTAHPUK (whaler's hat)

18th c.

Spruce root, red cedar bark, surf

grass, with yellow cedar bark lining

16/4130

HIGH-STATUS WOMAN'S

RAIN CAPE

n.d.

Cedar bark with

sea otter edging

15/5606

When we lose a family member, and a respectful amount of time to grieve has passed, we host the last feast or potlatch to honor him or her. Thlaakt'uultha marks the end of grief, usually one year after the death. Often the names and other privileges of the deceased are passed on to the rightful heirs.

Historically, we have been most at home on the sea. Recently, we have been all but excluded from the lucrative fishing industry. This has generated countless expensive court cases and much equally expensive and time-consuming political negotiation. Our ha'wiih and our elected leadership spend a great deal of their efforts asserting and defending our aboriginal title to traditional territories and the resources within them. Many times it seems our very beliefs and lifestyles are against the laws imposed in our own territories.

From 1884 to 1951, Canadian law forbade our people to practice potlatching. For nearly seventy years we could not celebrate the birth of our children in accordance with Nuu-chah-nulth law, nor the naming of our children, nor the coming of age of young women, nor the marriage of young couples, nor the seating of our chiefs, nor even the end of grief after a death. More and more, however, these powerfully meaningful traditions are coming out of hiding and into public light again.

Like our system of beliefs, our history of whaling is one of the great unifying forces in Nuu-chah-nulth communities. Whaling was never far from our grandparents' thoughts. In our mythology, the greatest whalers are the Thunderbirds. Every tribe has its own Thunderbird. It is said the Thunder-

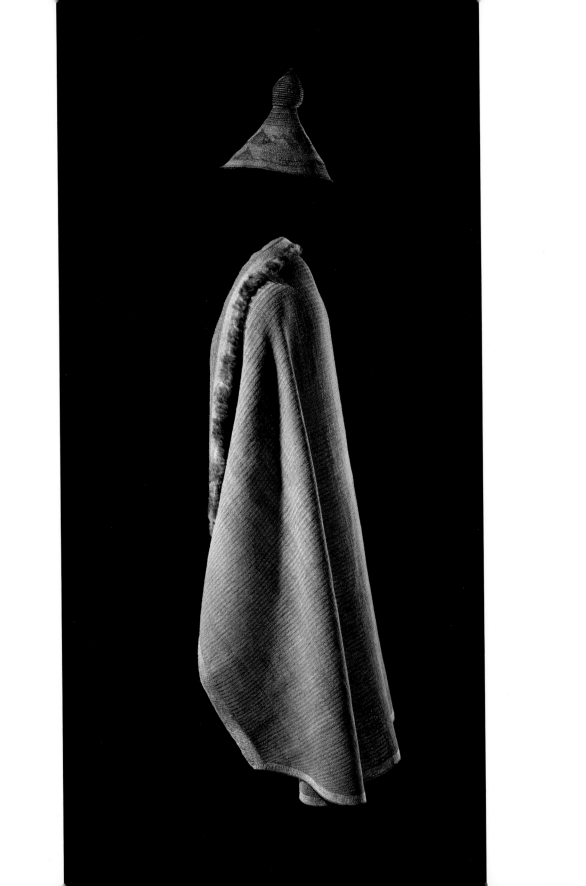

bird threw lightning bolts in the form of serpents at the largest whales, killing them instantly, then carried them off into the mountains to eat them. Great whalers from our villages likewise went out to sea and captured some of the largest whales in our waters. The success in whaling of these great men— their spiritual preparedness, knowledge, and physical strength—meant that they were able to feed their communities and invite neighboring tribes.

None of these great whalers, whose names say so much—He Gets Ten, He Always Gets Ten, He Always Has Lots of Blubber, His Beach Is Always Oily, Long Sounding Thunder, He Fills Up the Sea Between Islands and Creates New Land with the Bones of the Whales He Catches—could have won the achievements he did without the assistance of women. Mothers and wives played key roles in this most dangerous and prestigious pursuit.

Once a whaler's wife became pregnant, she prepared for a future whaler to be born. It was believed that her every movement affected the development of the baby. Great efforts were made to ensure that she was content and free of emotional stresses. She sat still in the company of whalers relating the events of the hunt and made sure the developing baby heard the whalers' legends and songs. When a boy was born, his mother continued to make sure he saw and heard everything particular to the life of a whaler. She would tap the bottoms of her baby's feet in time to the whale songs sung during the chu-uchalsh ceremonies after the successful harpooning of a whale.

As an adult, a young whaler could marry only the daughter of another whaler, a young woman ready to meet the expectations her high station imposed. She would be well aware of the proscriptions associated with successful whale hunts. She would lead a life of rigorous discipline and constant prayer. When her husband was out on the sea whaling, she would lie on a specially prepared mat, as still and quiet as she could be, praying that he would be successful and come home safe. If she allowed herself to get into an ill temper, if she got up and moved around, whatever she did, however she behaved, that was how her husband's prey would behave. This deep connection between the whaler's wife and the whale was acknowledged by all Nuu-chah-nulth whalers when they called whales Hakum, or Queen.

A whaler's wife also helped him at times during the last days of preparation before a hunting expedition. She accompanied him to his private place for ritual bathing. She might hold a rope fastened around his waist while he bathed in glacial pools, so that if he fainted, he would not drown. She might enter the ice cold water herself and imitate the swimming motions of a great whale, being careful to move slowly and gracefully. All such preparations would be accompanied by chants and prayers.

Women in the whaler's family prepared the cedar bark mats men knelt on while paddling their canoe in pursuit of their prey. Women separated whale sinews into thread-thin strands and later braided the strands into the finely finished lanyards attached to whaling harpoon heads. Women wove the whalers' hats so familiar to students of Northwest Coast cultures. Women

WHALING SCENES SHOWN ON

UU-UUTAHPUK (whaler's hat)

18th c.

Spruce root, red cedar bark, surf

grass, with yellow cedar bark lining

16/4130

dressed and tanned the bear hides whalers traditionally wore at sea.

At other times, whalers sequestered themselves from their families and village in a small wooden structure called a chii-asim (shrine). Here a whaling crew fasted together, bathed, and prayed. They also reminded themselves of all the successful whalers in their background. Some of these great whale hunters from the past were evoked by carved wooden figures. Others were represented by their actual skulls, set in particular places in the shrine. As the whaling crew prepared themselves to take the life of a huge whale, a spiritual act of the highest order, they prayed, surrounded by their most famous and successful ancestor whalers.

From before birth until death, we surround ourselves with a protective field of prayer. There is no human endeavor so elevated or trivial as to escape the need for prayer and discipline. All of the great Nuu-chah-nulth teachings are grounded in this simple truth.

— Ḳi-ḳe-in at Emin

Advice to my grandson

Don't sleep all the time. Go to bed only after having drunk water, so that you will wake up when you need to urinate. Eat once at midday, then go to sleep with that much food in you so that you will not sleep soundly. As soon as everybody goes to sleep, go out and bathe. . . .

Sit against the wall in the house working your mind, handling it in such a way as not to forget even one thing, that you may not wish to do evil, that you may not mock an old woman. Take up the orphan child. . . . Take him to your home and feed him well so that he will think highly of you. The children to whom you do so remember you when they grow up. . . . If you come to the beach with a canoe-load of wood, they will start unloading it for you and they will help pull the canoe up on the beach. . . .

Further, let me bring to you advice as to men's things. Be a carpenter, be a maker of canoes, for you would not be manly if you had to go about the beach seeking to borrow something in which to go out to sea. . . . Be a maker of bailers; be a maker of herring-rakes and scoop-nets for herring, for it would not be manly to lack them when you came to need things of that sort. . . .

I would say in advising her, if I had a girl, that she should also be willing to pick all kinds of berries and fruit, so that you may say to the old people, "Come and eat!" . . . If a person enters your house while you are weaving, let your workbasket go. Take a good mat and have him sit on it. Don't hesitate because you happen to have clean hands. Say that you will wash your hands when you are through cooking; let him eat. . . .

— *Tom Sayachapis (Nuu-chah-nulth)*

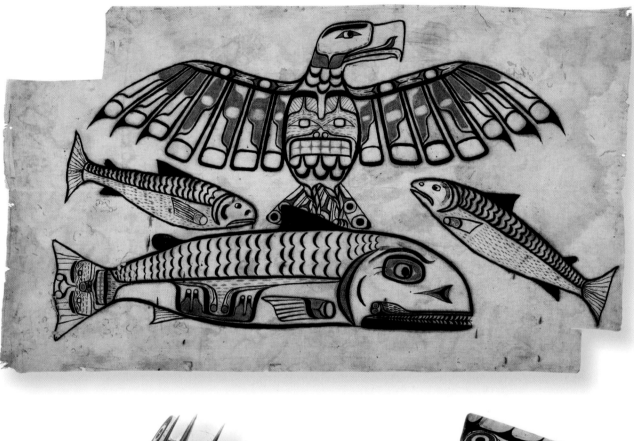
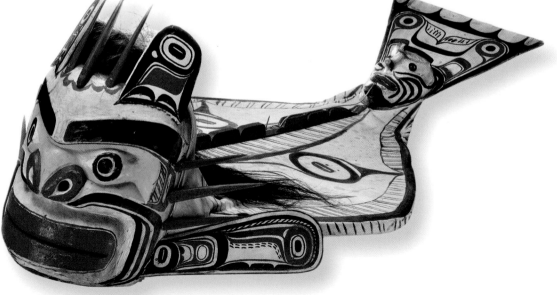

KWAKW<u>A</u>KA'WAKW

Our customs, our ways

When one's heart is glad, he gives away gifts. It was given to us by our Creator, to be our way of doing things, we who are Indians. The potlatch was given to us to be our way of expressing joy. Every people on earth is given something. This was given to us.

—A<u>x</u>u Alfred

Our people acknowledge every aspect of our lives through ritual and ceremony, from birth to death. Central to our way of life is our p̓asa, or potlatch. The most important aspect of the p̓asa is our Tse<u>k</u>a, or Red Cedar Bark Ceremonies. That is when people enter the spirit world to gain supernatural power and to connect to our history and dances. For these ceremonies, we enter our Gukwdzi, our Bighouse, where the firelight in the middle of the dirt floor sets the scene for drama and theatrics. Our ceremonial regalia and masks connect us to our ancestral roots and make us a distinct people.

We are the Kwakw<u>a</u>ka'wakw, the Kwak̓wala-speaking people. We are eighteen tribes whose territory reaches from northern Vancouver Island southeast to the middle of the island, and includes the smaller islands and

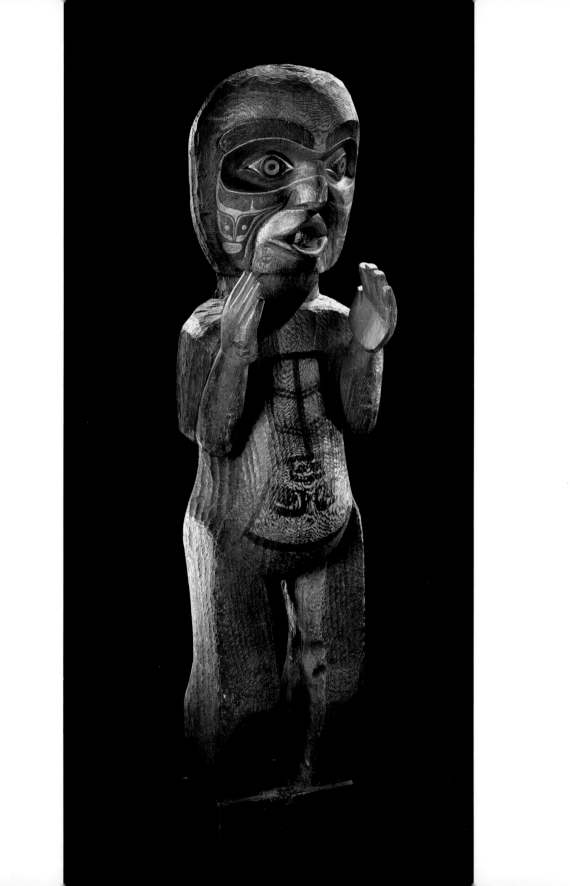

inlets of Smith Sound, Queen Charlotte Strait, and Johnstone Strait.

We, the 'Namgis tribe of the Kwakwaka'wakw, trace our origins back to the beginning of time. 'Namxxelagayu, a halibut-like monster, emerged from the mouth of our place of origin, the River Gwa'ni, or Nimpkish River, to get 'Namugwis, our First Ancestor. 'Namxxelagayu carried 'Namugwis to the bottom of the ocean during the great flood. 'Namugwis returned to the river and created a new beginning for our people. At the same time, Kwanu'sila, a thunderbird, and Xwaxwasa, a steelhead salmon, emerged upriver to build our first Gukwdzi. When a dancer re-enacts this story in the Bighouse, he wears a large figure of 'Namxxelagayu on his back. He dances bent over, a black cloth hiding his body, and moves the fish as though there were water above and underneath it. Traditionally, a small painted screen was held in front of the singers when this mask was danced. The screen might also have been held behind or in front of the dancers to dramatize the story.

FROM BIRTH, A LIFE OF CEREMONY AND RITUAL Every baby is considered a gift, a dɬugwe' from our Creator. At ten months a Hiɬugwila feast is held to honor the baby with his or her first Kwak'wala name and symbolically cut the baby's hair. Ceremonies are also held to ensure that babies are safe, and songs are sung to calm and soothe them.

Ixanttsila, the Puberty Ceremony, marks a pivotal moment in every young girl's life—her transition to womanhood. In the old days, to prepare for the ceremony, the young girl was secluded for sixteen days, tended by noble-

WELCOME FIGURE

19th c.

Carved and painted wood

11/5244

CHIEF'S COAT, worn for

ceremonial occasions

ca.1880

Cedar bark and cordage

18/6767

women in her village. She was taught to appreciate the gifts given to her by our Creator and shown how to conduct herself. Afterward, she was brought to the Bighouse to announce her passage into womanhood. Special songs, dances, and regalia, including blankets, leg bands, armbands, and hair ties, were made for her. The ceremony is very sacred and is held in high regard by our people. Coming of age remains an important event in a girl's life.

T̓SEK̲A: THE RED CEDAR BARK CEREMONIES Still close to the heart of our people are the dances, songs, and rituals we call the T̓sek̲a. We regard the T̓sek̲a so highly, it is like our mother, our Ada. These ceremonies mark important events for a chief and his family—from the birth and naming of children, to celebrating marriages, rights, privileges, initiations, and memorials. Guests who witness these ceremonies are served great feasts of salmon, halibut, seaweed, and oolichan oil. The host chief opens his g̲aldas, or box of treasures. Chiefs are groomed from birth to uphold family history and tradition. During ceremonies they pass this legacy to the next generations. It is one of the obligations and responsibilities of being Kwakwa̲ka̲'wakw.

The most important dance of our Tseḵa, the Hamaťsa, tells of overcoming Baxwbakwalanuksiwe', the great cannibal spirit at the north end of the world. The dance takes the dancer from a wild to a tamed state. The initiate begins by secluding himself in the forest, connecting to spirit and finding oneness. Upon returning, he enters the Bighouse in a frenzy, dressed in hemlock boughs. Attendants shake rattles to calm him. Whistles are heard but not seen. As the dance continues, the young hamaťsa is dressed in a red cedar bark headpiece, neck ring, and skirt to begin calming and taming him. Intricate handwoven neck rings, Tɬagaḵwaxwe', were created by the gifted hands of a cedar weaver. In the third part of the ceremony, a dancer appears wearing a Hamsamɬ mask representing the raven Gwaxgwakwalanuksiwe', who serves Baxwbakwalanuksiwe'. During the final part of the enactment, the tamed hamaťsa dances upright, wearing a cedar bark headpiece and neck ring, and a bear skin blanket.

TɬAGAḴWIWE'

(cedar bark headpiece)

1880–1910

5/401

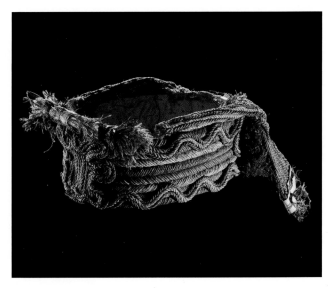

During the Red Cedar Bark Ceremonies, a dancer depicts Baḵwas, a supernatural creature that lives in the forest. Half the size of a grown man, Baḵwas has a green, hairy body, piercing eyes, and a hooked nose. He eats snakes and lizards, but cockles found on the beach are his favorite food. Baḵwas moves slowly, his body trembling with supernatural power. His hands are carved wood, and each finger of his carved hands represents a creature from the animal kingdom.

In the Tuxw'id dance, a woman related to the chief reveals her spiritual power by producing a długwe', or supernatural treasure. She can demonstrate her power through well-mastered theatrics by "birthing" her długwe'. She moves four times around the front of the singers and chiefs while they taunt her to prove herself. "What are you here for?" the chief asks. Finally, she reveals her treasure; this is crucial to re-create the spiritual power of the dancer.

ŁUK̲'WA (HOUSE DISH)

used during feasts

Mid-19th c.

Carved and painted wood

11/5239

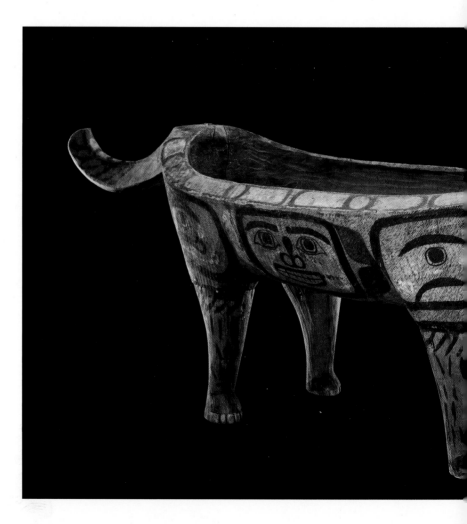

T̓ŁA'S̲ALA: PEACE DANCES In historical times the T̓seḵa and the T̓ła'sa̲la were separate ceremonies done at different times in the Bighouse. Eventually these two ceremonies were combined as parts of the modern-day ceremonies. During the T̓ła'sa̲la, or Peace Dances, special songs are composed for the chief, and his relatives and extended family members dance wearing carved frontlets with sea lion whiskers at the top. An ermine train flows down the back.

Following pages: Kwakwa̲ka̲'wakw Bighouse created by Chief Mungo Martin, David Martin, and Harry Hunt, and totem created by Chief Mungo Martin, Henry Hunt, and Tony Hunt, Thunderbird Park, Victoria, British Columbia

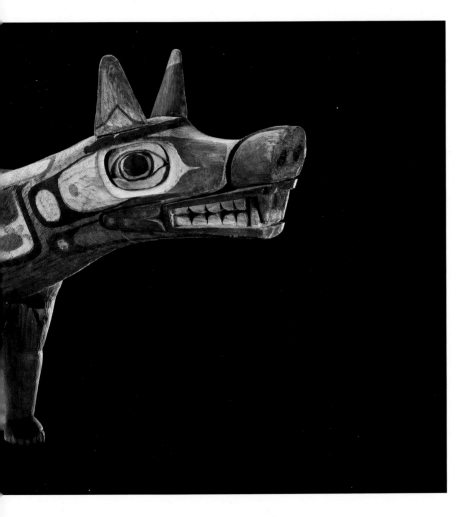

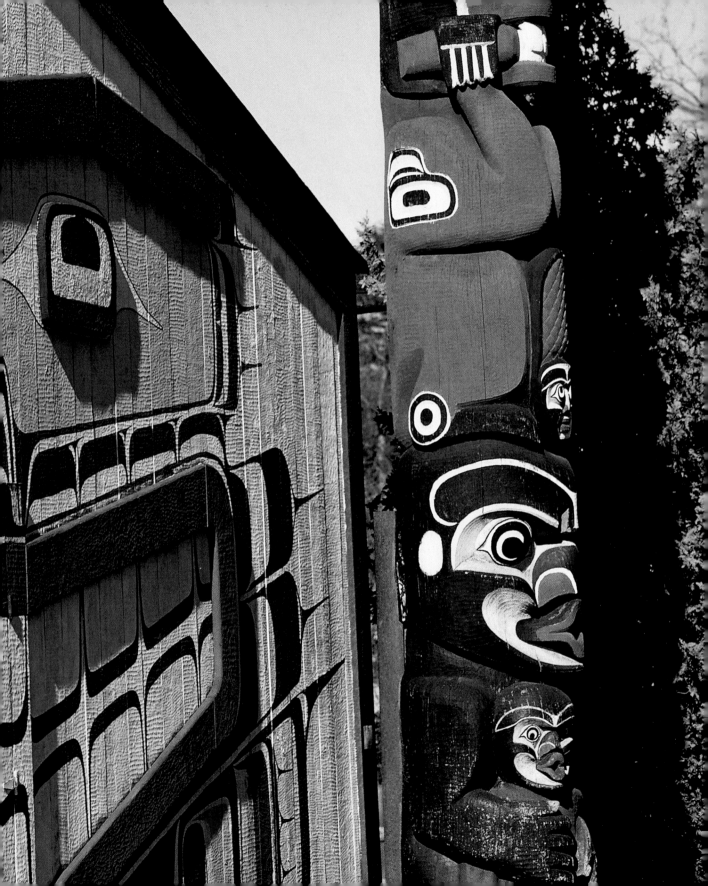

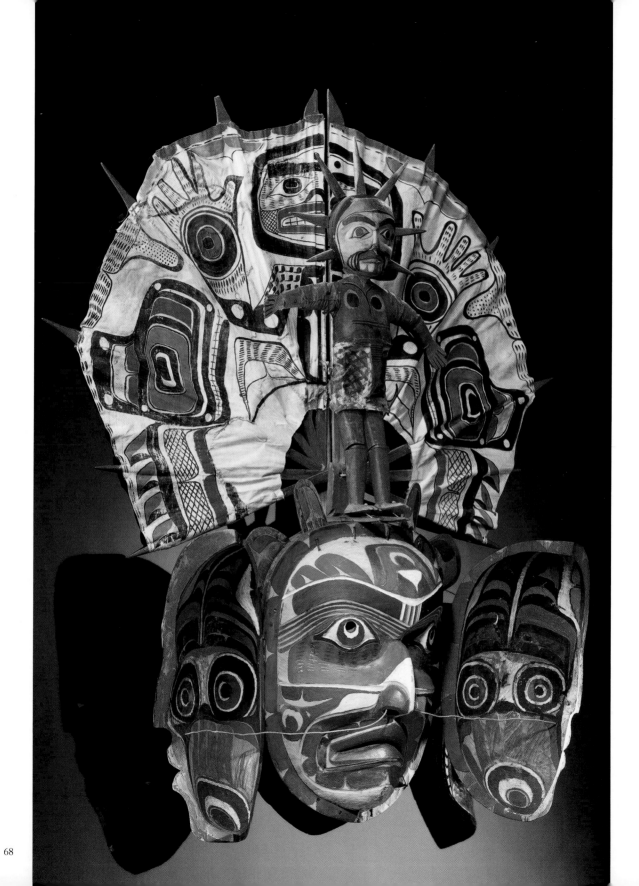

Eagle down inside the headdress floats to the ground, symbolizing peace.

Toward the end of the dance, one dancer runs out of the Bighouse through the front door. An attendant is sent to search for the missing dancer, but finds only his headdress. A masked dancer appears through the front door. This długwe', or treasure, enters, representing a mythical creature or animal from the land, sky, or sea. In ancient times, our people could transform themselves from human to spirit. This transformation mask, Tłisala Dałdałagamł represents Sanťła'yi (the Sun), who descended to earth in the shape of a bird, then changed into a man.

Master artists created our regalia and masks with a great sense of theater. Through the use of shells from the beaches, and animal skins and the great cedar trees from the forest, these masks, headdresses, and dance robes connect us to our traditional lands. They connect us to the supernatural world. When we enter the dance floor, we enter the spirit world, and we return to this world when the dance is done.

WE ARE STILL CONNECTED TO OUR ANCESTORS

In his introduction, Robert Joseph writes about the big potlatch my grandfather held at Village Island in defiance of the potlatch ban. Forty-five people were arrested and more than twenty were imprisoned. Charlie Hunt received a six-month prison sentence for making a speech. Herbert Martin: two months for dancing. Mrs. Johnny Nelson: two months

TŁISALA DAŁDAŁAGAMŁ

Sun transformation mask

1870–1910

Carved and painted wood, cord

11/5235

GIKIWE' (chief's headdress)

Made and worn by Chief Willie Seaweed (1873–1967), ca. 1949

Carved and painted wood

23/8252

FEAST SPOON WITH DZUNUK̲WA

(supernatural forest giant)

carved at top

mid-19th c.

Wood

18/4793

imprisonment for arranging the articles to be given away. Yet we continued to observe our ceremonies, celebrating in forests or on remote islands.

In 1953, the first legal potlatch since 1884 was hosted by the Kwakwaka'wakw artist Chief Mungo Martin at the Bighouse he built for the Royal British Columbia Museum in Victoria. The first new Bighouse built on Kwakwaka'wakw land was opened with a potlatch in 1966. Today our focus is to strengthen our language and culture, the very things that the government and missionaries tried to change.

Our language is taught in the schools, as well as community classes, with the goal to create a Kwak̓wala public radio station. We strive today to keep our traditions because our elders and ancestors worked so hard to save them. We strive to follow their path. We believe we are still connected to the spirit of our traditional past, and we carry that essence through our ancestral memory. We are where we belong. We are a living culture.

— *Barb Cranmer*

In 1921, Chief Dan Cranmer of the 'Namgis held a potlatch. The people who attended were arrested and tried under the anti-potlatch law, and more than twenty chiefs and elders were sent to prison. The trial proceedings included an illegal agreement that we would give up all the masks, coppers, and regalia used in our ceremonies. The Indian agent who acted as the judge removed these treasures. They were shipped to the National Museum in Ottawa. Some were sold to a collector for the Museum of the American Indian in New York.

The U'mista Cultural Society represents all the Kwak̓wala-speaking people in its ongoing work to repatriate our history. U'mista, which means a profound form of returning home, has filed a Specific Claim with the Canadian government on behalf of the Kwakwaka'wakw people to reconcile the effects of the anti-potlatch law. We have successfully repatriated most of our treasures from these institutions. One mask at the British Museum will be returned on a loan arrangement. Our treasures and the spirits of our old people will have returned—U'mista!

Gilakas'la—thank you—to the National Museum of the American Indian for offering us this opportunity to tell our history.

— *Chief William T. Cranmer ('Namgis)*
Chairman of the U'mista Cultural Society

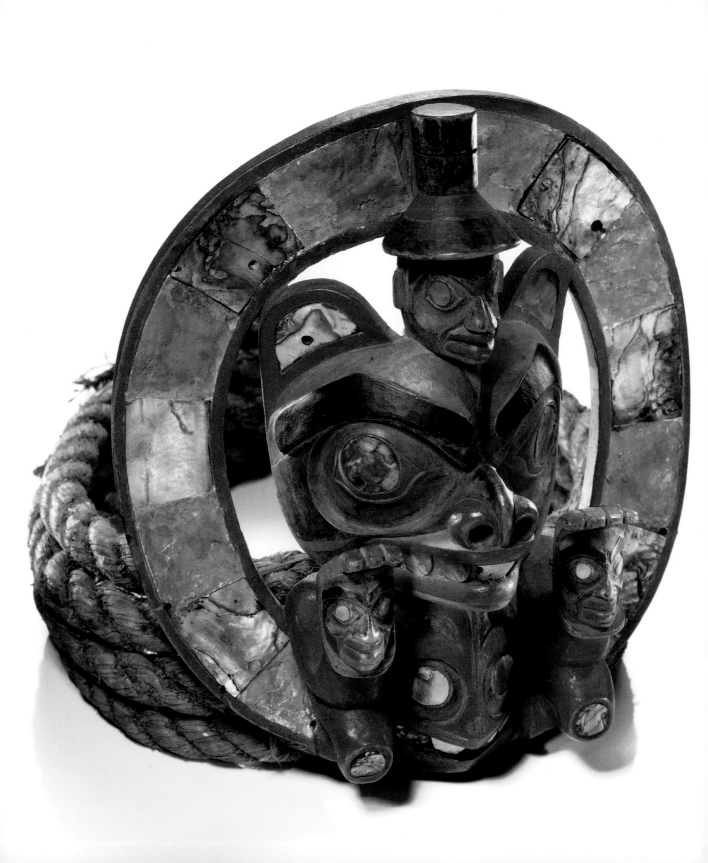

HEILTSUK

⊡

Uplifting our people

Our oral tradition tells us that the Creator set down the first generation of our ancestors in this part of the world before the time of a great flood. The title and rights to our lands were passed from the Creator to these original ancestors. Our territories cover 13,800 square miles of land and sea on the central coast of British Columbia. Historically, five tribal groups managed all our resources: the Wuyalitxv, or Outside People, of the outer coast and coastward channel and sounds from Cape Calvert Island to Milbanke Sound, the Goose Islands, and Outer Banks; the Wuilitxv (Inside People), who live on Roscoe Inlet and along part of Return Channel and Johnson Channel; the Qvuqvayaitxv (Calm Water People) of Seaforth Channel, Milbanke Sound, Spiller Inlet, and Ellerslie Lake; the Yisdaitxv or People of the Yisda, which includes Kimsquit and the territory along Dean Channel, Cousin Inlet, Kwatna Inlet, and Cascades Inlet; and the Xaixais of Kynoch and Mussel Inlet, Sheep Passage, Mathieson Channel, Finlayson Channel, Tolmie Channel, and Princess Royal Channel as far north as Butedale. Before European Contact, about 20,000 Heiltsuk people lived in our lands. In the

FRONTLET

Before 1880

Carved and painted wood,

cedar bark, abalone shell

11/3843

eighteenth and nineteenth centuries, we came close to annihilation by foreign diseases and social and economic forces. Now, we number some 2,000.

Our livelihood has always come from the ocean. We are expert at fishing for wild salmon, halibut, and shellfish; gathering clams and seaweed along the coast; and harvesting herring eggs. Waglisla, our principal community since 1890, is a fishing village. In the spring, when the sea comes alive, so does the village. Traditionally summer and fall were spent harvesting and preserving food. Winter was a sacred season for our ancestors, a time when the spirits came close to the villages. During the winter our ancestors held feasts and dance ceremonies to honor the supernatural world.

A NINETEENTH-CENTURY POTLATCH In his journal, William Fraser Tolmie, a surgeon and fur trader for the Hudson's Bay Company and one of the first Europeans to write about the people of the Northwest Coast, noted arriving at a Heiltsuk potlatch on November 27, 1834:

Qunnachanoot appearing in the forenoon & having left two hostages [to assure Tolmie of his safe return] I embarked in his canoe & we came in sight of the village, which is situated at the head of Kyeet's Cove; about 4 p.m. having in our rear 7 or 8 canoes....When opposite the village in the narrow channel, there took place a great shouting and bawling between those in the canoe and their friends on shore. From what I could gather—some expressed their disapproval at my coming but the greater number were

MODEL CANOE rigged out for a fur seal hunt with two hunter figures

ca. 1880

Carved and painted wood

1/8927

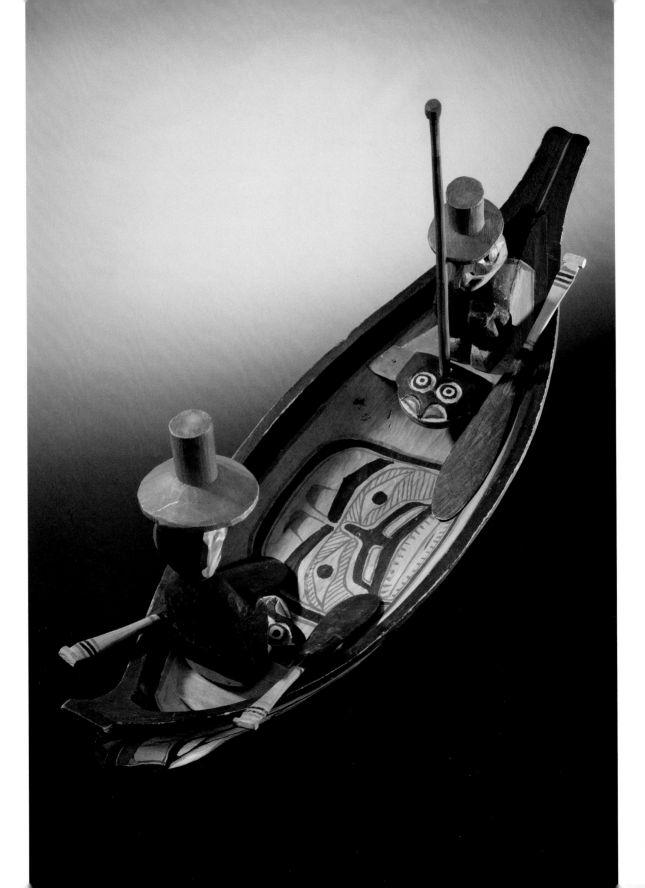

pleased and silenced the others by loud & angry expressions of disapprobation of their language.

Tolmie went on to describe the large "Conjuring House" where the potlatch was held. At one end of the house, a wall of painted boards formed a screen between the main room and the place where the dancers prepared. "Seated around the fire with brush & pallet were several artists giving the finishing stroke to the masks."

In the main part of the house, the chief sat on a wooden bench or settee in front of the screen wall, with members of his family and honored guests. "An immense fire burns in the middle," Tolmie wrote. The potlatch began with a welcome speech to guests, who were seated according to their status on three rows of benches running the length of the room. The speaker noted the chiefs who were not there and asked why they were absent. He asked the guests if they had come in peace.

Dancers, using raven rattles or clappers, and wearing headdresses, blankets, aprons, and leggings, emerged from behind the screen wall to dance around the large fire. Tolmie described dancers wearing carved and painted masks with human faces representing the ancestors. Others wore bird masks and were accompanied by attendants. After the dances, the chief distributed gifts, and his guests feasted on salmon, goat, and oolichan oil.

Understandably, Tolmie described the potlatch much better than he interpreted it. What he mistook for angry shouting when he arrived was the

BENTWOOD BOWL, used for serving meat and fish at feasts
Design attributed to Captain Richard Carpenter (1841–1931), late 19th c.
Cedar base with alder or maple sides, opercula shells
1/8074

potlatch hosts' and guests' greeting each other. Each group of canoes represented a different tribe or clan, and as each group came within sight of the beach, its members would announce who they were and where they came from, and ask permission to come ashore. At the same time, those on shore would return greetings and respond to the request for permission to land.

For all its marvelous spectacle, the potlatch was primarily a form of governance. Traditionally, only a chief could host a potlatch. As orators stood and recited their chief's privileges—the names, songs, stories, and dances owned by the house; its crests, history, and heritage; the extent of its lands and hunting and fishing grounds—guests tacitly confirmed the social relationships among houses, villages, and nations. Marriages, transfers of land-use rights, and other contracts were entered into.

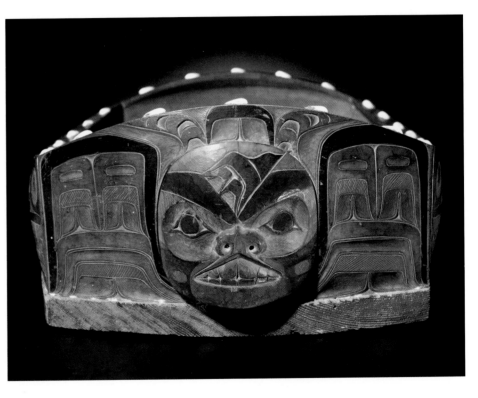

By banning the potlatch in 1884, the Canadian government undermined Heiltsuk civil society, as well as our ceremonial life.

RECLAIMING OUR HERITAGE Sometime after 1951, when the potlatch ban disappeared from Canadian law, we began to reclaim that part of our heritage. In the early '70s one young man from the community dedicated himself to reviving Heiltsuk dances and ceremonies by researching information and spending time with elders. He, his mother, and the chiefs and elders began practicing the songs and dances. They taught the children's dances to the

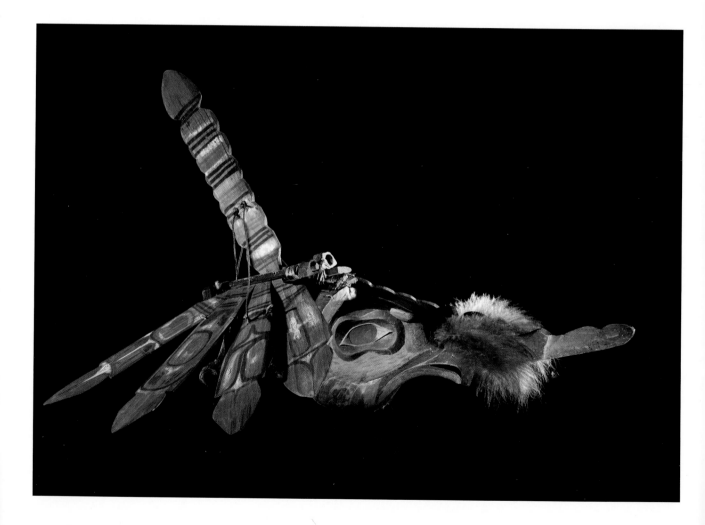

students in school. For the past twenty-six years, the school has hosted an annual Children's Potlatch so that the students can learn about potlatching. Parents and teachers have made a collection of blankets with school or family crests, so every child has a dancing blanket.

Once winter celebrations, potlatches today are held throughout the year. Invitations to a potlatch are made as soon as the host family has chosen a date. In the old days, messengers carried the chief's invitation to his counterparts in other villages, asking them to come to witness the potlatch. Now invitations are made with the announcements at another family's potlatch. There is no custom of the guests' sending regrets. It is assumed that everyone who can come, will come. It took my family two to three years to prepare for my father's memorial potlatch. We got together evenings to make dance blankets, tunics, and aprons for our family to wear. My sister's husband, Glen Tallio, and their son carved a portrait mask of my father, with the traditional Heiltsuk Eagle nose. Masks of this kind are used only once, then buried or burned.

A potlatch begins with welcoming songs from the hosts as the guests arrive in their own boats or on the ferry. People gather in the big house, community center, or school gym to hear the welcome speeches. The tribes in attendance and honored guests are acknowledged, and the reasons for holding the potlatch are given. A blessing is sought for all that will follow. The chiefs in attendance may perform a welcome dance, letting eagle down fall from their headdresses as a symbol of the right to peace that is inherited by all members of the human family. In the past, when the chiefs arrived for a

MASK WITH MOVING WINGS,

worn for the Weather Dance

ca. 1890

Carved and painted wood,

eagle feathers, cedar bark,

bird skin, cotton, sinew

5/767

FEAST BOWL in the form

of a canoe, possibly used

to serve oolichan oil

ca. 1860

Carved, incised alder or maple

9779

potlatch, they brought carved wooden bowls filled with food to be shared with their communities. Today feast bowls are presented as symbols to remind us of our traditions and responsibilities.

The potlatch is a chance to take care of family and community concerns. The first few hours are often dedicated to honoring those ancestors who have recently passed on before us. Headstones are unveiled, and the lives of the deceased are remembered. Then the ancestors' spirits are invited into the house to help us end our mourning. It is only proper for the dead to be remembered in this way, for the most important event to take place during a potlatch is the passing on of titles and positions from one generation to the next.

The ancestral titles we receive come down to us from more than 10,000 years of memory. They come from origin stories and other legends our families own and have the right to tell. When a baby is born, a child's name is bestowed during a potlatch given in the baby's honor. Then, when the child comes of age, a second name is bestowed and the baby name is passed on to a new child. A third name can be given when someone assumes adult responsibilities and begins to contribute to our society. These names may originate from either the mother's or father's side of the family, and their stories are told when they are given. In carrying our names, we carry the history and legacy of our people. Our titles entail the responsibility to act in the people's best interest.

Adoptions are also announced at a potlatch, to affirm individuals' importance to the hosts' house and recognize bonds of friendship. After being

adopted into a house, a person has the right to wear that house's crest at its events, but he or she is also expected to help the house whenever possible. Sometimes young people adopt elders as their grandparents. Washing ceremonies are observed, to help us put painful experiences behind us and find peace. Achievements are recognized and honored. In the past an outstanding hunter might have been given a name owned by his chief and the status that accompanied his new title. Today, we are likely to acknowledge someone's earning a scholarship or an advanced degree.

And then the dances begin. Barb Cranmer has given a brief description of the Kwakwaka'wakw Red Cedar Bark Ceremonies and the cannibal dance—which we call the Tanis—when a young man reenacts our ancestors' encounter with the wild man of the woods. In the Heiltsuk Winter Ceremonies, these sacred dances are followed by the Dhuw'laxa.

MASK TO BE WORN IN THE

CLAM DANCE

ca. 1900

Carved and painted wood,

with cord attached to open

and close the mask's shell

9/2227

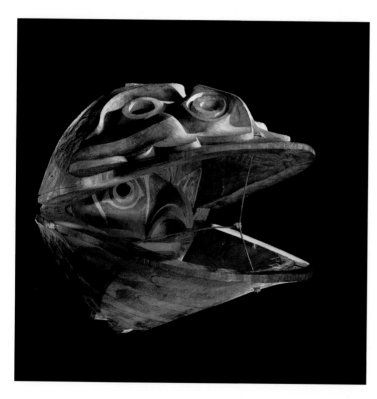

Dhuw'laxa means Returned from Heaven, and this part of the potlatch marks the reinstatement of the secular order after we have honored the spirits of the supernatural world.

The masks and the dances of the Dhuw'laxa come from the chief's treasure box. These masks and dances tell stories about how our ancestors met supernatural beings at the beginning of the world, and how the world was transformed into the shape it has today. They include references to the spirits of the elements, as well as the plants and animals around us. These references can be quite witty. In the Clam Dance, for example, a women's dance, clams come out to dance as people. When a real human being comes along, the dancers close their shells and become clams again. Good dancers don't need masks to turn themselves into clams; they can tell the story using their dance blankets to mimic clams opening and closing.

At the end of the potlatch, the host family distributes gifts to the guests. We were taught not to favor anyone during the gift-giving, although the first gifts go to the chiefs. We were also taught never to give gifts to our own family members. The gifts are a way of thanking people for witnessing the events of the potlatch. Giving gifts within the family would undermine the

validity of that affirmation (although there is nothing to stop us from getting together afterward to exchange thank-you gifts).

At the end of the potlatch, the hosts ask if they have failed to recognize anyone who should have been honored, and if so, we apologize and ask them to come forward. We ask if we have overlooked any payments we owe or other agreements that should be honored.

Sustaining the structure of the community was always a primary function of the potlatch. The act of 'káxlá, uplifting, comes from a ceremony given for a newborn child. The chief dances with the baby held aloft to introduce the child and create a place for him or her in the community and the house. Those present are asked to support and guide the child as he or she grows. Today, many elements of the potlatch have to do with uplifting each other.

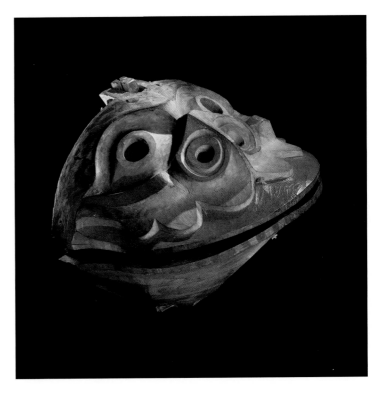

A THRIVING CULTURE Although Heiltsuk customs and traditions have evolved and changed over time, what has not changed is the chief's responsibility to act for the well-being of his house.

Many of the issues that concern us now have to do with protecting our title and rights to our lands. For centuries, for example, we have harvested

herring roe by collecting eggs that cling to the kelp in spawning grounds. In 1996 the Supreme Court of Canada confirmed our aboriginal right to harvest and sell herring spawn on kelp. All Heiltsuk have this right, including those yet to be born.

Despite setbacks and day-to-day challenges, ours is a thriving culture. Every summer, our children spend time at the site of one of our ancient villages on the Koeye River learning about their Heiltsuk identity. They learn the songs, dances, and stories, and how to gather and prepare foods in traditional ways. They also learn contemporary science and conservation. At the end of the camp, they hold a feast for the elders, to show what they have learned. The feast in 2001 was especially memorable. That year, with the help of Ecotrust Canada and the Raincoast Conservation Foundation, we purchased the only commercial lodge on the Koeye, an important step in our fight to protect the headlands of the Koeye and rebuild the salmon run there. Hundreds of Heiltsuk, Oweekeno, and Nuxalk people who came by boat were greeted by the campers. Then, the hereditary chiefs paddled down the Koeye to the beach in two traditional canoes. The welcoming that day is the image I would like to leave in your mind's eye.

— *Harvey Humchitt*

Why the Heiltsuk were called Bella Bella

And then these people from Old Town, ?Qelc, they go to a place where they call ?Kelemt—that's Strom Bay—'cause that's a reserve. And they go because everything's close by—the halibut, pretty short distance, and they get seals, seals and everything, mussels, clams close by. That's why they go there in the summertime.

And this big sailing ship landed there from South America. And the crew of the sailing ship asked them to do everything. They want a swimming race, swimming you know, 'cause it's a nice beach—it was Strom Bay. And the [Heiltsuk] boys from there just walk away from them, 'cause that's all they do—they swim all the time, see.

And after the swim race they want canoe racing, you know, paddle. They just go right away from them, you know, canoe.

Boat race last thing they do. They go right away from them.

And I say this to the people—I tell this to the white people in Vancouver: They must be a fine-looking people, and they call them Bella Bella.

That's where the Bella Bella come from, from South America, so that's a Latin word, you know—from Latin, "beautiful beautiful," that's what it means.

"Bella Bella." They named them "Bella Bella." That's where the Bella Bella comes from.

> — *Gordon Reid, Sr. (Heiltsuk),*
> *describing the arrival of the first schooner*

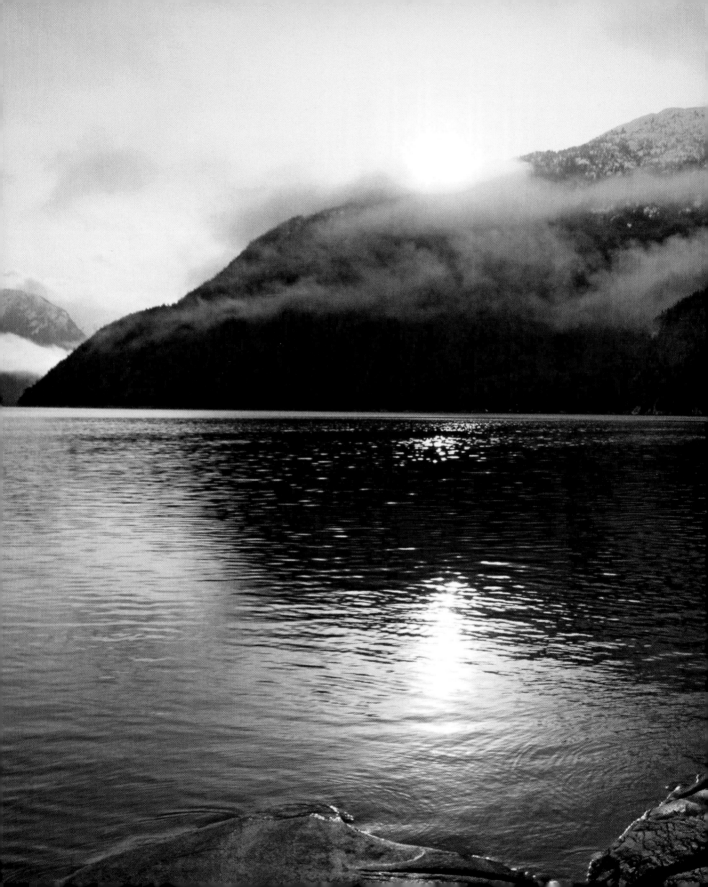

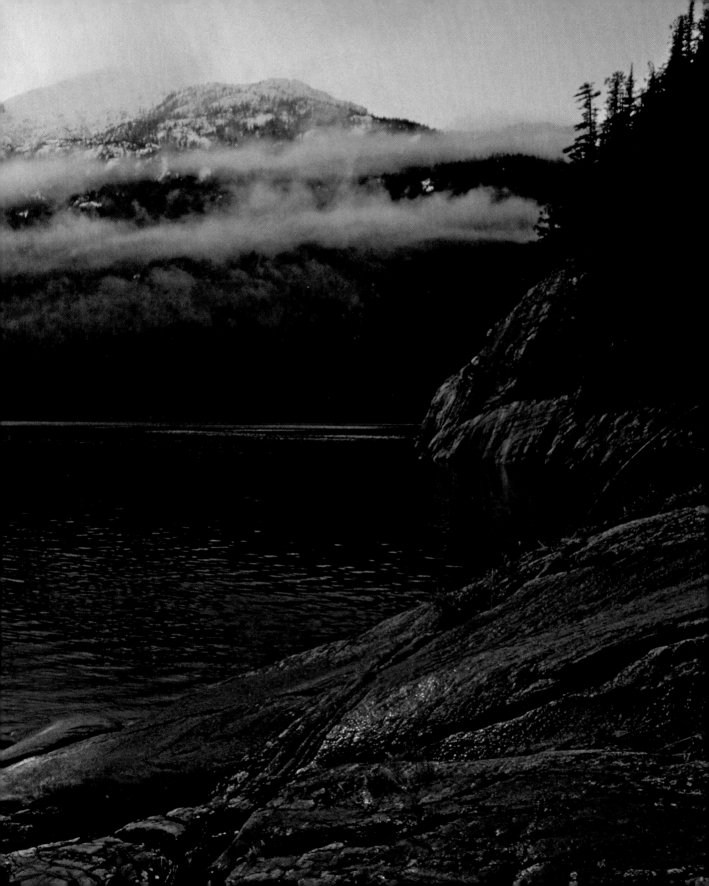

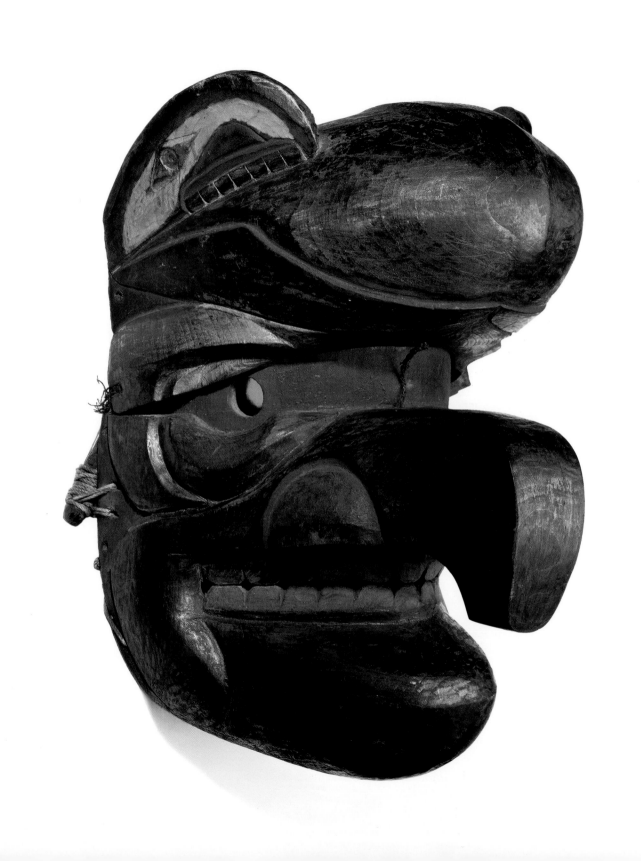

NUXALK

⊡

These treasures have kept our culture alive

We have chosen to show wood carvings made and danced by members of the two most important Nuxalk ceremonial societies. The sisaok society supported our ancestors' civil order. The kusiut reflected their religious beliefs.

According to our oral tradition, Älquntäm, the sky god and creator, sent the earliest ancestors to earth in the form of a raven, eagle, whale, and bear. Älquntäm had a great longhouse in the upper world where he kept all supernatural beings. There he asked his carvers to carve a man, and he gave the man life. Älquntäm took the man to a room of the longhouse where all the cloaks of animals and birds were kept and told him to pick out a cloak. Älquntäm also gave him the stories and dances.

Each ancestor descended to a mountain top with an ancestral name, food to feed the creatures that would soon inhabit the land, sea, and sky, and ceremonial knowledge learned from the world above. If he was an eagle, he came down as an eagle, and he had all the eagle stories and the dances that went with them. The ancestors then took on human form and came down to the

S7YULH (kusiut mask in the form of a Thunder figure)

ca. 1880

Alder, paint (possibly graphite), pearl buttons, and cord

19/838

Preceding pages: Elcho Harbour, off Dean Channel, north of King Island, British Columbia

foot of the mountains to establish villages and hunting grounds.

They found a generous home. The Nuxalk lands lie along the Bella Coola River, South Bentinck Arm, Kwatna Inlet, and Dean Channel. The rivers and inlets provide salmon, oolichan, and other seafood. The mountains offer hemlock, spruce, alder, cedar, and other species of trees; wild berries throughout the summer; and game for meat and furs.

At Nusqalst, people mined a green stone, hard enough to make adzes and chisels, which was highly valued in trade. You can find trees there that bear chisel marks 200 and 300 years old, where people tested the wood to see if it was solid enough to be made into canoes. In the spring, Carrier and Chilcotin people living in the mountains to the east followed the Grease Trail to the valley to trade for oolichan oil.

Ałquntäm told the first people that as they accumulated great wealth—in the first days, wealth was chiefly food—they should give much of it to others, rather than see it go to waste. By their gifts, they would spread knowledge of their names to other villages.

Only wealthy chiefs and their families could join the sisaok society. Initiates were expected to compose and sing songs about their families' history, and to dance at potlatches where their families' crests were publicly displayed.

Although guests from other villages are sometimes invited to other ceremonies, at potlatches they are essential. At potlatches, members of the sisaok performed ceremonies related to inherited prerogatives, marriages, funerals,

QWAXW (sisaok mask representing a raven)

Mid- to late 19th c.

Alder, glass, vermilion, bluing, and paint

14/7487

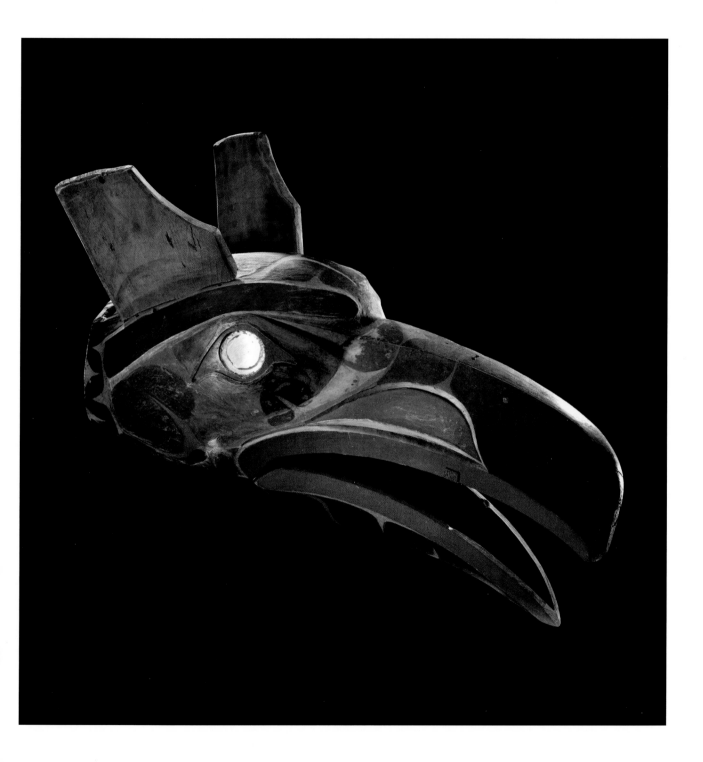

name-giving ceremonies, and the raising of totem poles. The validity of these rites depended on the fact that guests witnessed them and accepted the hosts' gifts. Sisaok frontlets, masks, and rattles informed the guests at a feast of the wearers' status and family origins. Sisaok dances were usually stories of transformation from the mythical animal ancestor of the long-ago past to the high-status family of the present day.

In the fall, four days after the September moon was full, members of the kusiut society began preparations for a series of ceremonial potlatches that would begin in November and continue nearly every night until March. Membership in the kusiut signified an individual's connection to a supernatural being (siut). The membership of the kusiut, called kukusiut, encompassed society from chiefs to commoners and slaves. Knowledge of the society, however, was highly privileged. The uninitiated were not to know kusiut secrets, but were instead to be awed by the presence of supernatural beings during kusiut dances.

Thunder is the senior kusiut among the supernatural beings:

Long ago, long before the white man came to this land, but still longer after the first settlement, four brothers left Kimsquit to hunt mountain goats on Mt. Tcaqoɬekx', near the Kimsquit River. It was September; the goats were plentiful, fat, and unsuspicious, so that before

nightfall, the brothers had killed four. Well satisfied, they lay down in a cave to sleep for the night. At that time, no one knew what supernatural being caused thunder; the earliest inhabitants of the world had possessed that knowledge, but it had been forgotten in the intervening generations.

Towards midnight, the hunters were awakened by a loud boom and wondered what could have caused it. Presently they saw approaching a figure resembling a man, with a weird nonhuman face, who carried in each hand a huge rock crystal. He raised and lowered his arms as if pounding; at each movement the crystals struck each other, producing the booming sound and emitting a flash of light. The eldest brother, Saiks, told the others to cover their faces with their blankets and to keep their eyes closed, because some evil and powerful creature was drawing near. But the second brother, who had caught

7AMATUUTS (feast dish) in the form of a beaver, used by chiefs

ca. 1890

Alder or maple, paint

19/8964

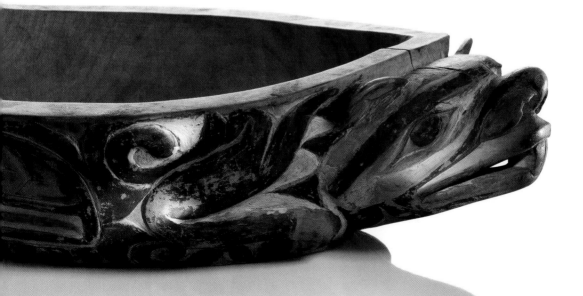

SINAAXWMIIXW (sisaok

headdress)

ca. 1860

Alder (?), abalone, glass, brass,

vermilion, bluing, and paint

23/4612

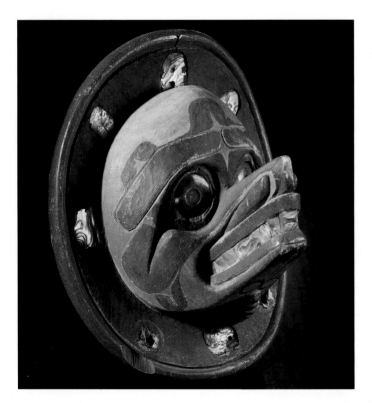

a glimpse of the two crystals and greatly desired them, watched cautiously, hoping for an opportunity to steal them. Thunder, for it was none other, ranged around; at intervals he passed across to the other side of the intervening valley on a sidewalk that grew from his feet to form a bridge for him, and on it, too, he was able to retrace his steps. Several times Thunder crossed and recrossed, accompanied by reverberating peals. He came near the four brothers and danced; then lay down while fire emerged from his nostrils. The second brother began to feel scorched. Gradually the heat increased, but he was powerless to move; before dawn, when Thunder vanished, he had been roasted to death.

The three survivors buried the dead man in a hastily made grave in the floor of the cave and went home, abandoning the mountain goats they had killed. Saiks, though grieved at the loss of his brother, felt that the latter's death was his own fault for peeking when he had been warned not to do so. Not long afterwards the two younger brothers died. The sole survivor told a carpenter to make him a mask secretly, according to a design which he would describe. In this way, the face of Thunder was portrayed in wood. When the mask was ready, Saiks wore it and gave an imitation of the actions of his patron; no one had ever seen anything like it, and the people were amazed.

In the dance, Thunder first appears standing on a wooden box, so that he seems very large. His regalia includes hemlock branches with eagle down suspended in the boughs; an imposing mask trimmed with cedar bark; a blanket with feather designs; a cedar bark neck ring possibly hung with weasel fur; cedar wrist and ankle bands; and a dance apron. After twisting and turning in place for several minutes, blowing through his teeth, Thunder jumps to the

SINAAXWMIIXW (sisaok headdress) representing a raven
Late 19th c.
Alder (?), glass, vermilion, bluing, paint, and string
19/9030

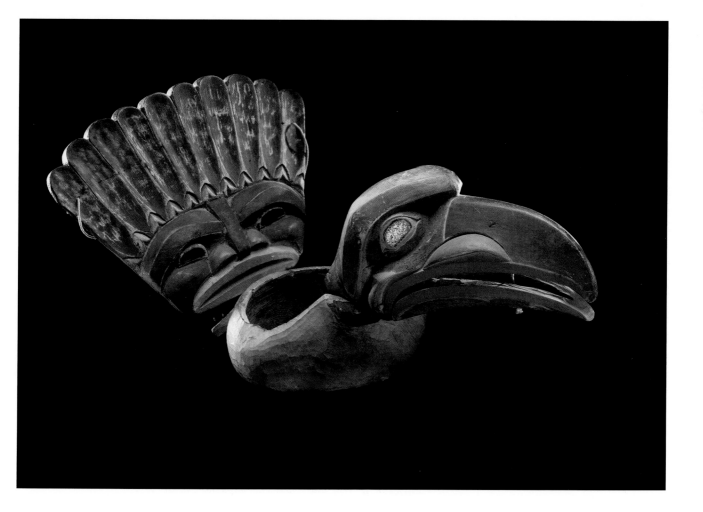

floor accompanied by a peal of thunder, a sound made by kukusiut rolling stones about in wooden boxes out of sight of the audience. Thunder dances around the fire bending and rising, shaking and stamping violently to the accompaniment of the thunder boxes. All Nuxalk dances move in the direction of the sun, in honor of Älquntäm. Because this physically demanding dance is repeated four times, Thunder is played by four different dancers, one of the secrets unknown to those outside the kusiut.

Eleven other masks or dances originally accompanied Thunder: the Announcer, Sun, Defamer, Rainwater, Drum-Beater for the Yearling Goat, Winter Wren, Rabbit, Mosquito,

Two Raindrops, Snail, and Two Clowns. Despite individual embellishments, kusiut masks can be identified by similar symbols or aspects. For example, Thunder has a bulbous forehead and is colored with graphite pigment, while the Announcer has diagonal stripes across his face. The Eagle incubus, another kusiut mask in the museum's collections, is carried under the dancer's arm. Like the Hao Hao, the great Cannibal Bird, in the dance the Eagle incubus uses its movable jaws to bite people in the audience, as well as to make noise.

Depending on the wealth of the society, the kukusiut might hire carvers and have masks made during the potlatch, then burn the masks after the dances were finished. These masks may have been somewhat crudely carved and painted, for hundreds were made in a few days, often by men working through the night. Masks that were not burned—perhaps because they were made by more highly paid carvers, or perhaps because the kusiut was not so very wealthy— were hidden very carefully during the spring and summer, making their appearance again only during the winter ceremonies. Kusiut masks were regarded as particularly powerful because the stories connected to them, their workmanship, and their animation were controlled by a select group of people, lending everything associated with them an air of mystery.

QWAXW (sisaok mask representing a raven)
Late 19th c.
Alder, glass, vermillion, bluing, paint, cord, and metal
14/7488

The sisaok and kusiut societies, which played important parts in Nuxalk life for thousands of years, barely survived the nineteenth century.

In 1793, twenty years after European and American ships began to sail the waters of the Northwest Coast and seven weeks after Captain George Vancouver explored Nuxalk inlets, the Scottish explorer Alexander MacKenzie arrived in the Bella Coola Valley on foot. MacKenzie had followed the Grease Trail through the mountains, becoming the first non-Native to cross the American continent.

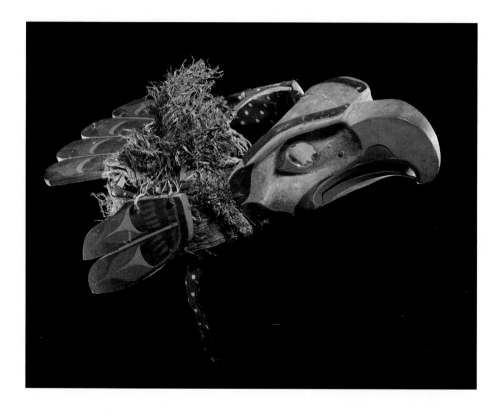

In less than a hundred years, epidemics of smallpox, influenza, and other European diseases against which we had no natural immunity reduced the population of the coast by more than 90 percent, from an estimated 185,000 in 1770 to fewer than 35,000 in 1870. Nearly half the Nuxalk people died in the smallpox epidemic of 1836 and 1837. More than half the remaining population died of the same disease between 1862 and 1863. Whole villages were left empty of living inhabitants.

Yet those who remained continued to tell many of the stories, and our generation has worked in libraries and museums to reconstruct cultural knowledge that otherwise might have been lost. We are grateful for the research done by Canadian ethnographer Thomas F. McIlwraith, whose account of our Nuxalk stories, ceremonies, and daily life during the 1920s has been valuable to us.

We are grateful to our elders, as well. Lil remembers being in her teens when one elder lady asked her if she would like to learn the traditional dances. Lil said she didn't think so, but the elder insisted, saying, "I've seen you dancing the jitterbug. You can do this." Lil's dance group later took part in a competition in Vancouver. They borrowed the Hao Hao masks that remained in Bella Coola and made dance regalia. Eighteen Native groups entered the contest, but ours were the only dancers who had masks and who had learned the old songs, and we took home all the prizes.

Some of the old ways cannot be revived. If our community restricted the right to use crests, songs, and dances, many of these things would never be seen again, for the families that owned them have disappeared. Yet Harvey has carved kusiut masks and burned them after they were danced—the first Nuxalk carver in a long time to do so. Alvin studied at the School of Northwest Coast Indian Arts in 'Ksan in order to teach Nuxalk arts at Acwsalcta, our new school. The school teaches our language as well, and several of the students are essential to our dance group.

The school's halls are decorated with portraits of the students' grandparents

SINAAXWMIIXW (sisaok head-
dress), re-curved beak
suggests an eagle
ca. 1880
Alder (?), red cedar bark, glass,
vermilion, bluing, paint, and cloth
19/843

and great-grandparents, elders who worked to see the school built and who share our pride at all our young people are accomplishing there.

We have lived here for millennia surrounded by other nations. Yet our masks are different, our songs are different, our stories are different. These things were given to us at the beginning of time, and they have helped keep our culture alive.

— *Harvey Mack, Alvin Mack, Grace Hans,*
Lillian Siwallace, and Eva Mack

An inconsiderate son-in-law

A man who is giving a ceremony of any kind can offer few greater insults to his wife's relatives than omission to ask for their assistance. . . .

About 1900 a man and woman were married and had three children. Then the mother died. . . . Four years later the husband proposed to marry once more and to have the wedding occur at a potlatch. But on the day of the *xläxtnim*, he insulted the relatives of his dead wife by failing to invite them. The cause of the feud was not disclosed, but the husband increased it by failing again to invite her family when, during the potlatch, they should have rebought her for the benefit of his young relatives about to be initiated into the ranks of the sisaok. The father of the dead woman came forward uninvited with a large present for each, saying in effect:

"I, too, have a right to contribute to add prestige to my daughter and her children."

In this way he defeated the wiles of his son-in-law who had hoped to shame his father-in-law by the failure of the latter to contribute to his potlatch. The son-in-law endeavored to excuse himself by saying that his late wife's relatives had not assisted for so long that he thought they would not wish to do so. This retort further incensed the father of the dead woman so that the next day he and his wife publicly gave the donor of the potlatch $300 "to make clean where we sit."

— *Told by T. F. McIlwraith*

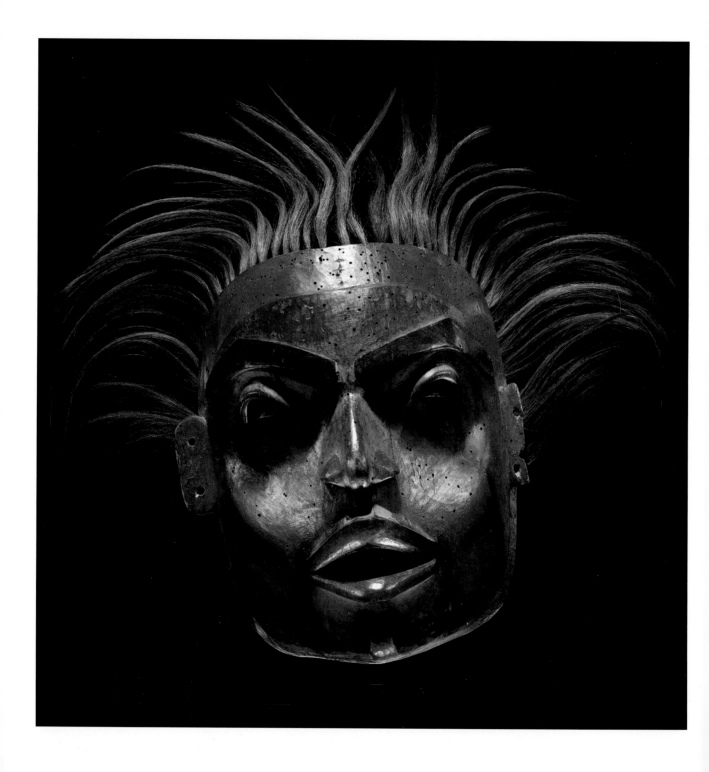

TSIMSHIAN

▣

The strength of the people

Laxyuubm Ts'msyeen, the Land of the Tsimshian, encompasses the great Skeena River watershed of British Columbia from the Pacific coast east to the Skeena Mountains, and all the coastal lands and offshore islands north to the Nass River and south to Douglas Channel. Through the lineages within each of the thirteen Tsimshian villages or tribes—Kitkatla, Gitwilgyoots, Gitzaxłaał, Gispaxlo'ots, Gitando, Gitlaan, Ginax'angiik, Gitsiis, Kitsumkalum, Gitnadoiks, Kitselas, Gitk'a'ata, and Giluts'aaw—we have owned these lands for more than 10,000 years. Our identity is much greater than who we are as individuals. When we introduce ourselves, we give our clan, our village, and our house, confirming that who we are arises from our connections to the land, to our ancestors, who lived here before us, and to each other.

This identity has developed over millennia to embrace all that we see around us. We feel close to the earth and all its inhabitants, and we acknowledge the spirits in all things. We honor these spirits in our dzapk, or crests, which we inherit, with all our rights and privileges, from our mothers'

AMIILK (mask)

Early 19th c.

Carved and painted wood

with hair attached

3/4678

AMIILK (mask)

1880–1920

Carved and painted wood

with hair attached

20/2325

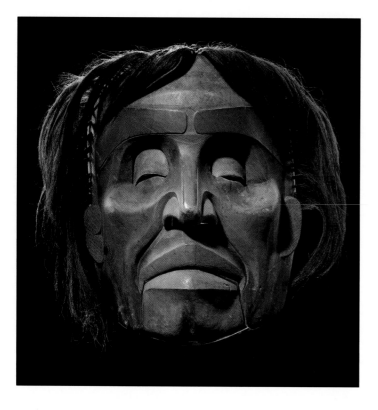

lineages. From childhood through the rest of our lives, our crests accompany us. We are Raven; we are Eagle; we are Wolf; we are Killerwhale. We are Tsimshian.

We chose the mask shown on page 102 at the beginning of this chapter to introduce the Tsimshian people in part because of its great artistry, but also because it speaks to our understanding of our relationship to the spirit world.

The eyes of the mask look to see the spirits that lie behind material reality. Seeing and hearing are important to our culture; people who do not take the time to look and listen mindfully are considered unworthy. Seeing and hearing properly lead to understanding and wisdom.

SEEING WHAT CANNOT BE SEEN
Many nations throughout the Northwest Coast convey the importance of seeing by making masks with eyes that open and close. Of all the members of Tsimshian society, the shaman is the most powerful seer. Calling upon the help and protection of the spirits, he sees beyond the present world and uses his insight to look after the people.

Through abstract images, too, Tsimshian carvers, painters, and weavers capture more than what is seen—the essence of things and their interrelatedness.

The central face depicted on the Naxeen, or Chilkat robe on the next page conveys the consciousness present in all living things. The recurved beak of a ceremonial or war headdress represents contained power that can be released at will. An extended tongue, usually associated with the Frog, communicates wisdom and understanding to human beings. These are some of the iconic images and concepts central to our way of being in the world, and they are found on the ceremonial regalia of all our lineages.

Crests, on the other hand, are owned by specific lineages and clans and commemorate moments of great political and spiritual significance in the life of the group. Some crests are so ancient that they are shared by all the lineages in a clan; others are specific to only one or two lineages. Crests are depicted on totem poles—pts'aan—in housefront paintings, on interior house posts, on ceremonial headdresses, robes, bowls, and spoons, among many other objects.

HISTORIES AND CRESTS The origins of our crests are recounted in our adawx, oral narratives that record important events and periods of Tsimshian history. Adawx describe the migrations of the Tsimshian people and the establishment of our communities. They recount conflicts and alliances with neighboring nations

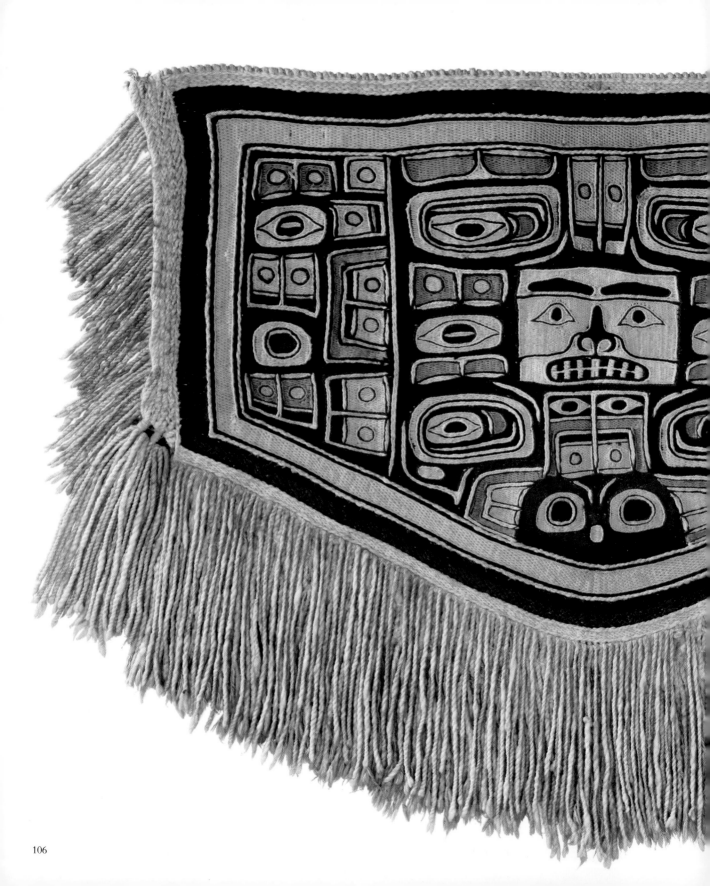

NAXEEN (Chilkat robe)

ca. 1880

Twined wool and cedar bark

23/4980

Following pages: Early morning on the lower Skeena River, British Columbia

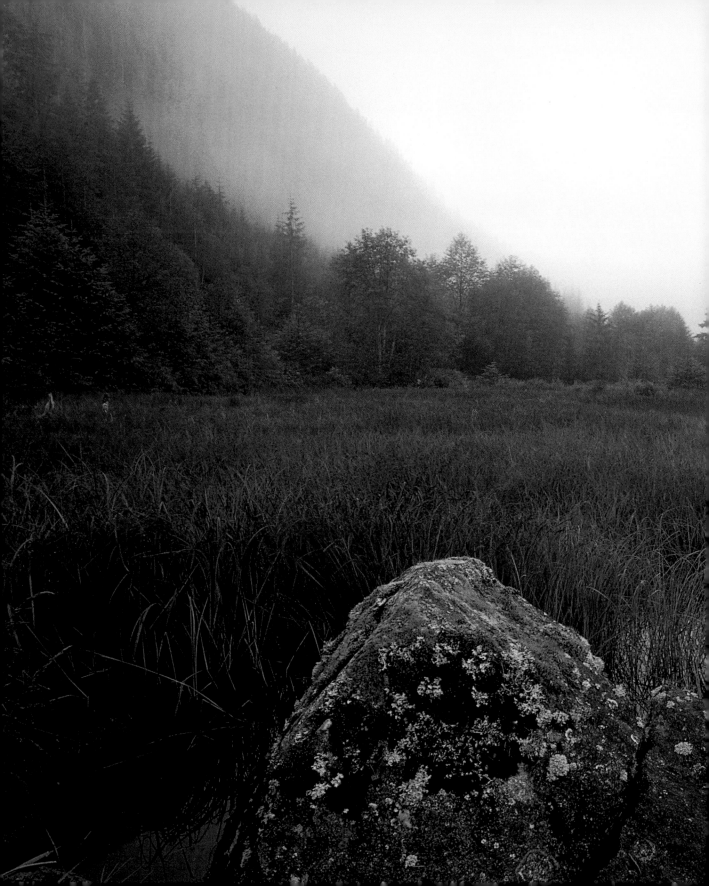

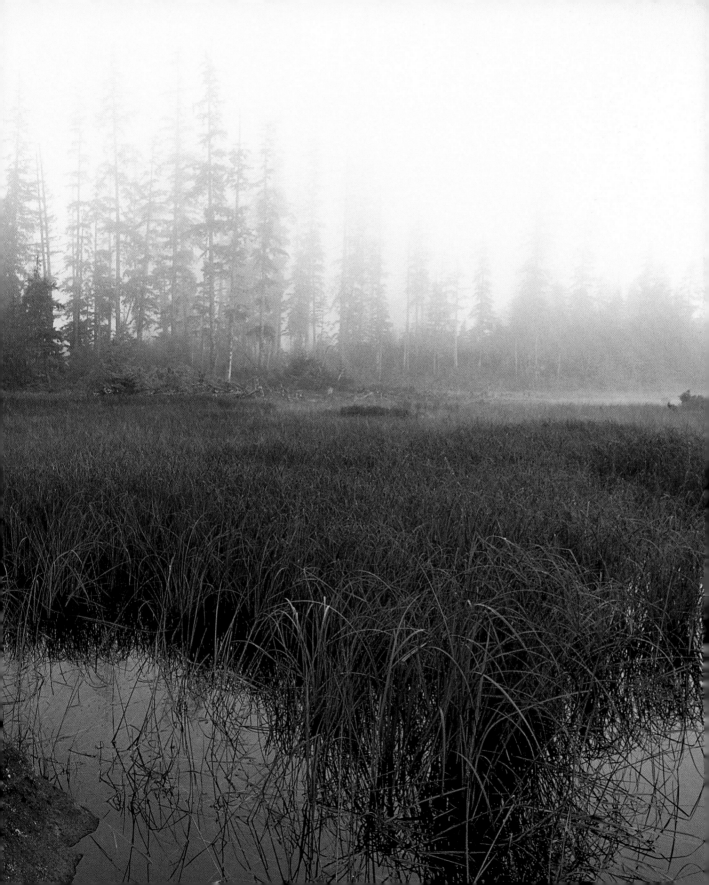

AYAA (dish) in the form

of Raven

19th c.

Carved wood

9/8039

and explain the origins of our clans. In every generation, adawx are reaffirmed in feasts—luulgit—during which chiefs recount their lineages' ancient narratives in the presence of chiefs from their own and other nations. Through these feasts, the chiefs know their own histories in the context of those of other lineages, clans, villages, and nations. This historical context defines current social, political, and economic relationships, and shapes decisions that will affect those relationships in the future. The legitimacy of territorial holdings, the nature of marriage and clan alliances, access to trade, status, and wealth—all flow from the historical identity of the lineage, clan, and nation. Adawx also contain ancient songs—limx'oy—expressing losses endured during times of hardship. Limx'oy are sung in the archaic language in which they were composed, but adawx are always told in contemporary language. Through them, we follow a straight line from the present back to the beginning of time.

Gatgyet, literally "the strength of the people," arises from a lineage's history and place in the world. In ancient times, when an ancestor first acquired a territory, a cane was sometimes touched to the ground to signify the power of the lineage merging with that of the land. A totem pole, on which crests are carved, is also planted in the ground. Our adawx, then, are not merely remembered events retold from time to time on ceremonial occasions. They record and perpetuate the very fabric of our society. Our crests are manifestations of our lineages' history and rootedness in this place.

In this bowl, Raven, the crest of every member of the Raven Clan, is seen in its most universal form, holding the sun in its beak as it prepares to release

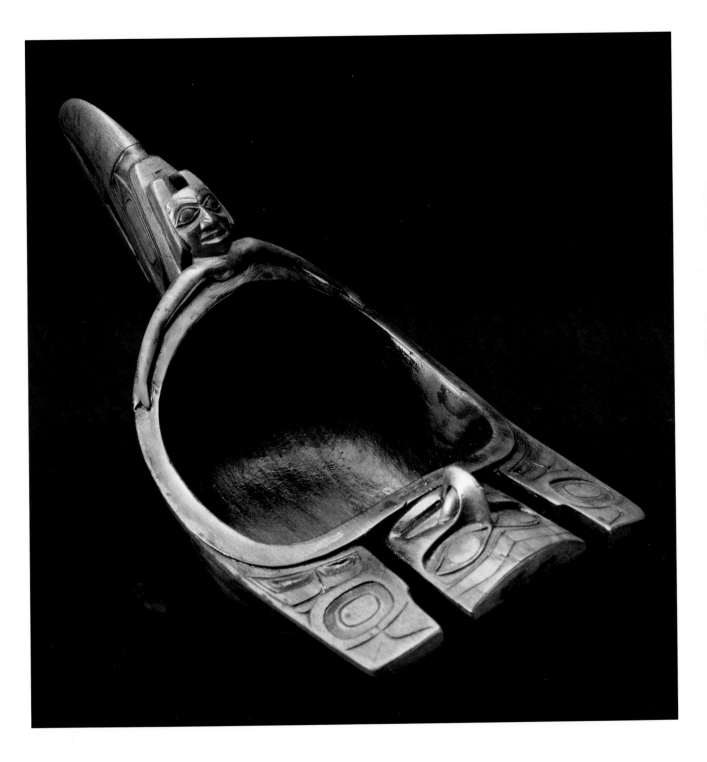

AMIILK REPRESENTING

MAXHLAKP'IIꞭMXSGIIK (head-

piece representing Over Ten Eagles)

ca. 1875

Carved and painted wood

1/8020

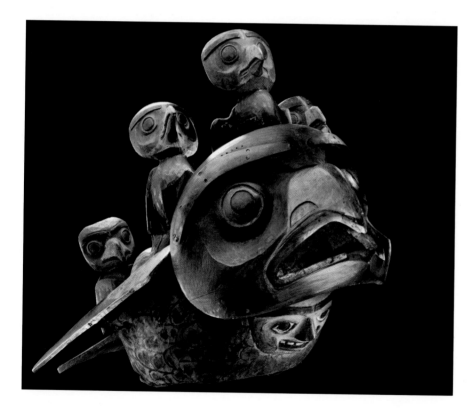

light into the world. Carved on the Raven's tail is the spirit being with the recurved beak, which—together with the human being represented on the Raven's head—echoes the imagery seen on ceremonial rattles used by many Northwest Coast chiefs. The Frog, too, is an ancient and important crest used by many lineages of the Raven Clan.

In contrast to the Raven, the crest Maxhlakp'iiꞭmxsgiik (Over Ten Eagles), shown on this headdress, is specific to only one lineage of the Eagle Clan—the lineage led by the chief Lutguts'amti. One of the founding peoples of the Kitkatla tribe, Lutguts'amti's lineage was among the earliest to help establish the Tsimshian nation thousands of years ago. As recounted in the lineage's adawx, the Over Ten Eagles crest represents a hagwilo'ox, or supernatural being from the undersea world, that appeared to a group of Lutguts'amti's people while they were hunting sea otters. On top of the ocean spirit's head was an eagle with nine young eagles on its back. The people were almost overcome by this supernatural being when the warrior Gilasgamgan sang the power

song of his lineage and appeased the hagwilo'ox with a gift of mountain goat fat. When the people returned safely to their village, they commemorated the event by creating a headdress, and they formalized this new crest by holding a feast. These acts established that the hagwilo'ox now shared its power with the people of the lineage and would protect them and their hunting grounds. In the very early days, a branch of this same Eagle Clan group moved to join another lineage, led by Chief Nisxło. Together these two lineages established several tribes on the middle Skeena River. Here they encountered a beaver spirit and took it as their crest. It is called Gamnaga'isksts'oo, Chewed Remnants, in reference to beaver sticks. The museum's ceremonial headdress bearing the Gamnaga'isksts'oo crest was owned by a nineteenth-century chief of that lineage.

Like the Raven Clan, the Killerwhale Clan has two crests that date back to the beginning of Tsimshian history and are used by almost all their people: the 'Neexhl (Killerwhale) and the Midiik (Grizzly Bear). This ceremonial war helmet is topped by an ermine skin, a sign of a high-ranking

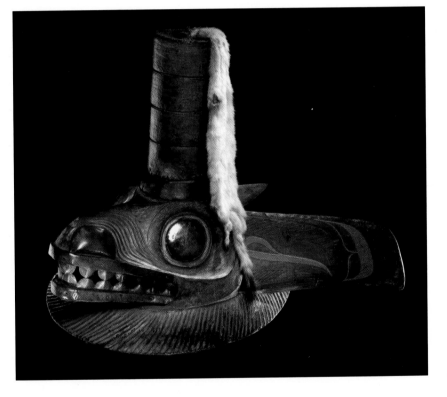

GALKMIDIIK (ceremonial or war headdress representing Grizzly Bear)

ca. 1870

Wood, opercula shell, copper, cloth, spruce root, ermine skin

11/1741

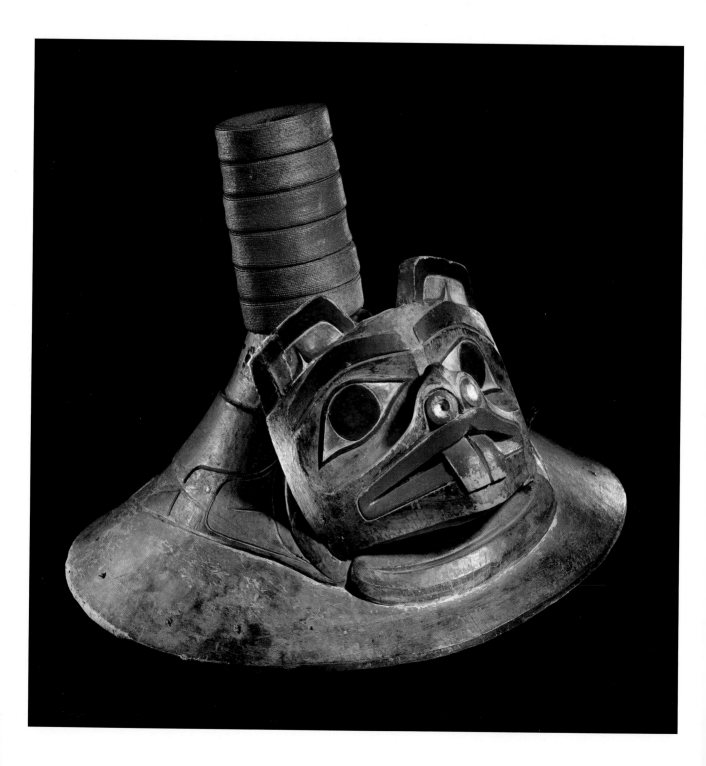

chief of the clan. The four spruce root rings indicate the number of impor-
tant feasts the chief has given, and a headdress with them is called a
lanmgayt. A second Killerwhale headdress in the museum's collections
shows how another artist portrayed the same crest in a very different way,
emphasizing the fin of the whale and its blow hole. A third clan helmet—the
Galkmidiik or war headdress with the Grizzly Bear crest that belongs to
several Kitkatla chiefs—evokes a spirit that protects the warrior and gives
him strength. War helmets often include locks of shaman's hair, which would
also offer the warrior spirit help.

While the Grizzly Bear crest belongs to the Killerwhale Clan and indicates
a lineage with upriver origins, Black Bear (Sami) crests belong to the
lineages of the Wolf Clan and relate back to the clan's ancient Bear Mother.
This ceremonial hat with six feast rings is probably the Gaydmsami (Hat of
the Black Bear) owned by Chief Walsk of the Gitsiis tribe; the protruding
tongue in this case usually indicates a black bear. Haaytgmsami (Standing
Bear) is a crest of the Wolf Clan chiefs Hlabiksk of the Kitkatla and Asagalyaan
and Walsk of the Gitsiis. A third Wolf Clan crest represented in the museum's
collections is the Gi'ik. Owned by Chief Walsk and Chief Niskyaa of the
Gitzaxɬaaɬ, the Gi'ik is the only Mosquito crest among the Tsimshian, given by
a Haida chief to his Tsimshian wife and children in ancient times.

We chose the bowl shown on the next page from the museum's collec-
tions because it combines matter and spirit in a piece of great simplicity and
strength. What cannot be seen surrounds us in all things, not only in

GAYDMSAMI (ceremonial head-
dress representing Black Bear),
owned by Chief Walsk of Gitsiis
1870–1900
Carved and painted wood,
spruce root
2/9165

ceremonial treasures, but also in the grace and complexity of objects of everyday life.

When we look at these objects, we see the pride of the Tsimshian people. We do not speak of pride in the past, as something that is gone or has been lost. Our way of being and our view of the world continue to define us. We are still here, still carrying our crests with us. The representations of our identity used yesterday and today are separated only by time. They still hold the heart of the people within them.

— *Lindsey Martin, Susan Marsden, and William White*

GREASE DISH

ca. 1880

Carved wood

9/7881

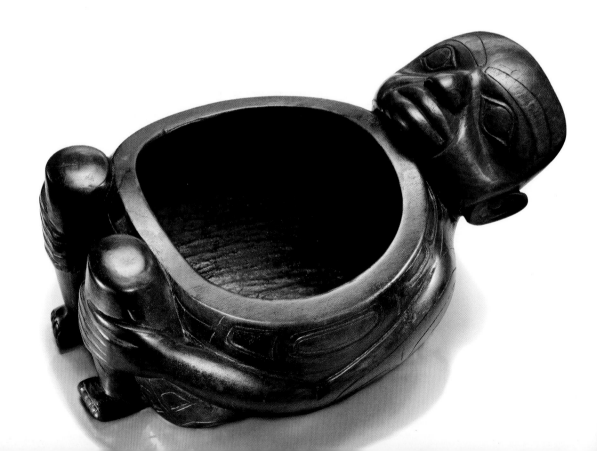

"Take your time eating, Chiefs."

Then the guests started to eat. As soon as they started eating, one of the leading Gitsiis headmen stood up and said, "Take your time eating, Chiefs, take your time eating, for this is what your grandfathers did. And the meat you are eating is mountain goat taken from the valley of Kiyaks."

Then another stood up and said, "Take your time eating, Chiefs, some of this meat is the seal meat the chief himself caught in his seal traps at the headwaters of Kts'm'at'iin, his own territory."

Then another stood up and said, "Take your time eating, Chiefs, these are the high bush cranberries and crab apples which you will eat gathered by the chief, my master, at his own berry grounds at Kts'mkwtuun."

Then they finished naming all the rivers owned by the Gitsiis so as to make them known to the tribes of the Tsimshian, that is why they spoke this way.

—William Beynon,
The Feast of Nisyaganaat, Chief of the Gitsiis

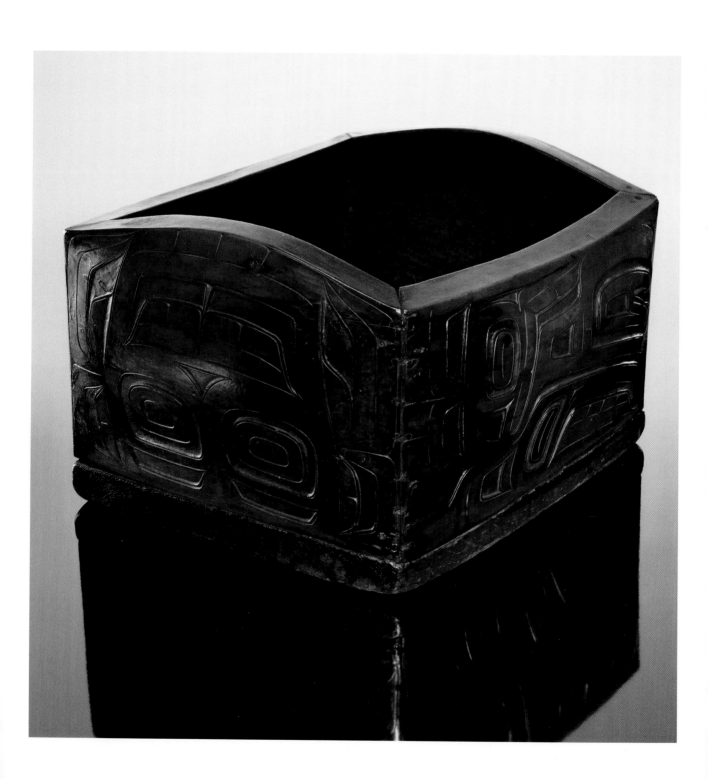

NISGA'A

I will send you a messenger

Every year since the beginning of our history, to save us from starvation and to continue our existence, God gives the Nisga'a the oolichan, or halimootkw—the savior fish. We are Nisga'a, the people of Lisims, the Nass River. We have chosen to share with you our story of survival, and to tell it through the tools of the oolichan fishery.

Oolichan, sometimes called candlefish, are members of the smelt family, small, silvery fish that spawn in the rivers of the Pacific Northwest. We call them savior fish, because they return to the Nass River at the end of winter when, in the past, our stocks of foods were near or at depletion. Not so long ago, the oolichan saved our ancestors from starvation. Even today, for three or four weeks in March, a temporary village springs to life at Fishery Bay as families fish and process oolichan.

In early times, before dip nets were invented, oolichan fishing was done with herring rakes, long poles studded with spikes from crab apple trees. By the late nineteenth century, most fishermen had begun to cut holes in the ice on the river and to set large, funnel-shaped nets on long wooden poles in the

BENTCORNER FEAST DISH FOR SERVING OOLICHAN OIL

Early to mid-19th c.

Carved wood

1/4325

OOLICHAN NET

ca. 1910

Twisted nettle fiber

1/4265

PACK BASKET

Late 19th c.

Maple bark and animal hide

1/4280

river channel. After the ice broke up, fishermen continued to work from canoes, using dip nets. Today, people fish from motorboats using seine nets, as well.

Fishery Bay is the only spot on the Nass River where oolichan are gathered. One of the principles of Nisga'a philosophy is the common bowl. Not all of our people are net-makers; not all of our people are fishermen. So those who do fish and do make nets give what they can to others. As eagles and gulls ride the air currents overhead, fishermen ferry their catch to processing shacks on shore. Dried and smoked fish, and especially oolichan oil, remain important sources of trade throughout the coast. Being a part of the oolichan fishery each year ties us to our ancient history. The fishery is so important that we have protected it by treaty.

The oral history of this fishery begins with Wii-Gat, a person born of Nisga'a and supernatural parentage. Wii-Gat brings us daylight, and he secures the oolichan fishery every March for our people. Through his teachings, we have learned to catch, process, and use the oolichan, while remaining ever mindful of conservation for future generations. My grandfather told me this

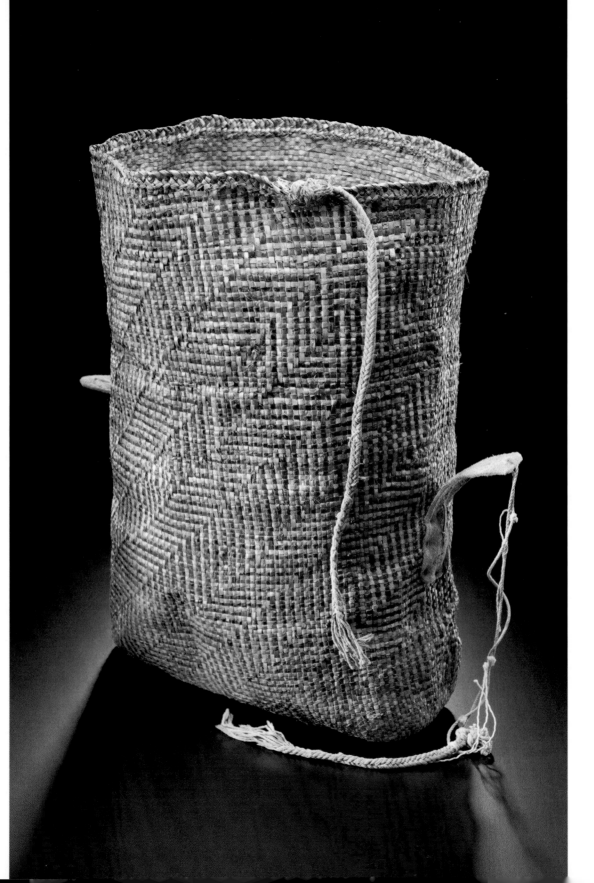

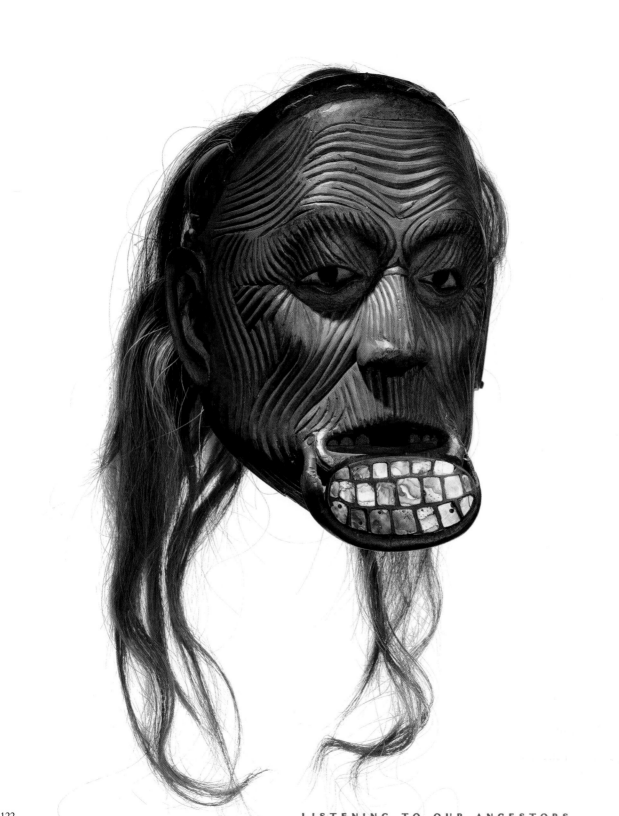

story, and my father has told it to my daughter, who is three. In her own retelling, "Wii-Gat brings the light to the world. He brings the light to the school, and he brings the light to the Wal-Mart"

DIM HIJIY DIMT AN HLIMOOMSIM—I WILL SEND YOU A MESSENGER Before there was daylight, when the world was in semi-darkness, before there were many trees here, when the water of Lisims was like a lake, a baby was born into the Chief of Heavens' house. Slipping from his mother's grasp, the baby fell to earth. There he landed on the funeral pyre where only days before a chief's grandchild had been cremated. The chief's wife, who had come there to mourn, said, "My loving grandson, returned from the dead," and took him to her house, where the chief adopted him as his son. "Look after him carefully," the chief said. "There have been many who have been resurrected."

The boy grew but did not eat, until a visit by Laax'woosa'a, a sea monster. Disguised as an old man, Laax'woosa'a slipped food into the boy's mouth, igniting his appetite. "Oh, this boy is going to be all right," Laax'woosa'a said. "He is going to be big, strong, and tall, and also very smart and resourceful. Because he came back from the dead, he will be strong indeed and able to do anything." The boy had a voracious appetite, and so to save his people from starvation, the chief decided the village must move. The boy was abandoned on the shore, and the people wept as they pushed their canoes away. Now having to fend for himself, the boy took many journeys in search of food.

MASK REPRESENTING

AN ELDERLY WOMAN

OF HIGH RANK

ca. 1850

Wood, abalone shell, hair,

semi-tanned leather, tanned

leather, iron alloy, and twine

9/8044

One day, he came across Mask'ayaa, the bullhead salmon, and challenged him to come closer. The bullhead named him Wii-Xwdayim-Gat, "a very hungry person," his name from that day forward.

One day, as Wii-Gat walked along the lakeshore, he could hear oolichan fishermen talking. Wii-Gat pleaded with the fishermen to share their catch. The fishermen ignored him and refused him food. Wii-Gat returned to his original village and prepared to travel to the house of his grandfather. At the Chief of Heavens' house, he headed for the pond and wished for his mother to appear. Transforming himself into a pine needle in the water, Wii-Gat managed to be picked up in his mother's cupped hands, so that when she drank she swallowed the pine needle.

Soon after that, Wii-Gat's mother told her husband she was going to have a baby, and before long Wii-Gat was reborn. The Chief of Heavens was very pleased with his grandson, cuddling him, playing with him, and singing lullabies to him. The chief gave the baby anything he cried for and let him play with the max, a ball that hung on the wall in his house and contained the daylight. Each day the baby played with the ball, and each day he moved closer to the door, until one day, he played with the ball outside. Transforming himself back to his true form, Wii-Gat grabbed the max, and with all his might ran and jumped into the opening that would bring him back to earth, shouting, "Wii-Gat ran away with the max!"

Now Wii-Gat returned to the oolichan fishery and asked the fishermen to take pity on him and share their food. Once again, they ignored him and

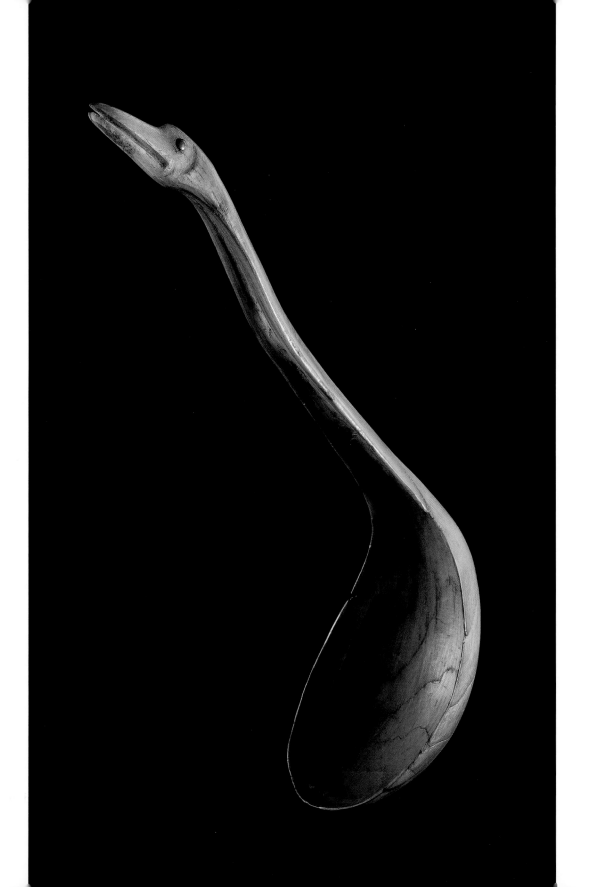

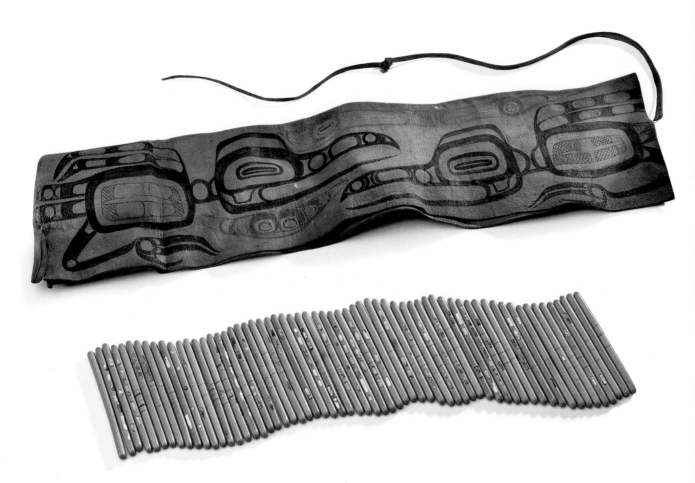

continued their work. Wii-Gat warned them that he would release the daylight if they did not share their catch, and still they ignored him. On his fourth warning, Wii-Gat tore open the max, releasing the light to the world. When his eyes adjusted, Wii-Gat could see many boxes floating on Lisims, and the fishermen were gone. In the light of day, Wii-Gat could see more clearly and searched for food. He understood then why his grandfather had abandoned him, and he held no resentment.

Wii-Gat journeyed down the coast to a sbi naxnok, or house of supernatural beings, near what is known today as Hlgu Ul, Little Bear, to gamble.

It was the month of Xsaak, or March. Wii-Gat brought with him his andaxsan, a mat woven of ash tree saplings, and haxsan, a game made of small round bones. When he reached Hlgu Ul, he submerged his canoe beneath the cliff. When he reached the bottom of the sea, he left his canoe near the house of the chief who held all the oolichan in four bags, one in each corner of his house, protected by guardians.

"The slime and oolichan spawn of Wii-Gat's dip-nets splashed me," he said, entering the chief's house. "I hardly slept as a certain person caught three canoe loads of oolichan last night." The other gamblers laughed, calling him a liar. "How could that be," they said. "It's not time for the oolichan for months yet." Until then, the oolichan had run in June. But Wii-Gat told them to check his canoe. He had prepared very carefully. He had tricked a sea gull into coughing up a herring, and he had smeared his canoe with herring eggs that would look like oolichan spawn.

The others returned admitting Wii-Gat told the truth. Enraged, the chief said, "If those big fools are giving away oolichan! They are supposed to look after them and keep them protected in my house!" Seeing no alternative, and hoping Wii-Gat might be swamped and drown, the chief ordered, "Let them go!" The guardians unleashed the oolichan and Wii-Gat escaped, shouting to the oolichan, "Head for Lisims! Swim upstream on both sides!" Wii-Gat paddled up Lisims shouting, "Wii-Gat did it! Wii-Gat got the oolichan running now! In March!" He was extremely pleased and hungry as he hurried home to cook oolichan for supper.

GAMBLING STICK SET AND CASE

Mid to late 19th c.

Wood, abalone shell, and

painted animal hide

9/8116

Wii-Gat developed the oolichan fishery and taught all the techniques to the Nisga'a of Lisims. He showed us how to use rakes and nets. He taught us the different schools and runs of oolichan that return to the river each year, where they break and surface, where the best raking and dipping sites are. He told us how the river used to be like a freshwater lake. Wii-Gat taught us about the other animals that come into the estuary with each oolichan run— the sea lions, whales, killer whales, seals, right down to the lowly sea gull. He taught us to watch for signs, like the talking of the Litskw, or mountain grouse, which always coincides with the arrival of the oolichan at the mouth of Lisims. Our ancestors learned to keep track of these things. It was their livelihood, and it all began with Wii-Gat and his enormous appetite.

This may be the place to tell how our ancestors were given the name Nisga'a. When the oolichan appeared in Lisims, so too did thousands of other animals, and people from other nations. They all came to eat. And the words for the lips are nisk, the upper lip, and tl'aak, the lower lip. In March, humankind and every other creature came to Lisims to use their lips. So the river valley became known to outsiders as Lax Nis-Ga'a, for all the eating that was done here every spring.

There are

many other stories about Wii-Gat, but this is the last about the oolichan. Wii-Gat's cousin Logabuulaa came from 'Ksan—that is, the Skeena River, south of the Nass—one day to visit him on Lisims. The two cousins often competed to see who was more skillful, more powerful, and so on.

On this day, they chose a bow-and-arrow competition. They planned to sit on the shore and shoot at a target on the far side of the river. The target was a crevice on the face of a cliff, barely visible from where they were. And Wii-Gat bet that if he lost, the largest portion of the annual oolichan runs would go to 'Ksan—the Skeena River. Logabuulaa took the first shot and watched the arrow float across the stretch of frozen river. "I hit the target, brother!" he said. Wii-Gat shot next, and his arrow fell short of the cliff and lay on the ice. But Wii-Gat said it was impossible to tell which arrow was which, at such a distance. The two cousins argued and could agree on nothing other than the fact that there was only one arrow in the target.

Wii-Gat suggested that they let the crows be the judge. They could fly over and report which arrow was which. Wii-Gat had given the crows instructions on how to behave before the competition started. The crows swarmed all over the target, making such a flurry that Logabuulaa could not see them pull his arrow out of the cliff and put Wii-Gat's there instead. The crows all flew back making an excited racket and announced that the identity of the arrow was not clear, that they should both see for themselves.

As the two cousins crossed over the ice, each fully confident he would win, they finalized the wager. They agreed the majority of the oolichan

would go to the victor's river, with only enough for eating going to the loser. To be fair, the loser would get the fattest spring salmon runs. They stepped up to the crevice and behold! Wii-Gat's arrow was in the target and Logabuulaa's on the ice nearby. Logabuulaa was certain that his arrow hit the target, and he felt tricked. Before leaving to return to his river, Logabuulaa expressed his anger and resentment by telling Wii-Gat that henceforth he would be called Txeemsim because he was a deceiver, a cheater, and one who always asks for things but never gives anything in return. Wii-Gat became known as Txeemsim, he controlled Lisims, and the oolichan run here every March.

There are many more stories of Txeemsim. These are the ones the Council of Elders wished to share.

— Allison Nyce

GREASE DISH IN THE FORM

OF A FROG

ca. 1880

Carved maple or alder

1/4275

Following pages: Sockeye salmon

returning to the river to spawn,

British Columbia

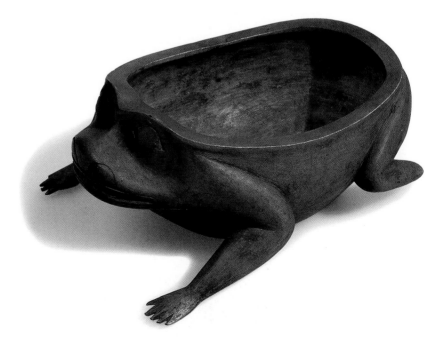

"This will be left with you."

I am pleased with you for being able to get this information from me while I could still remember. I will not hesitate to tell you what you want to know because I only have a few days left before I leave this earth. This bit of information on how our grandfathers and great-grandmothers lived will be left with you. If I have more time in the near future, I will tell you more about how foods were preserved and a few more laws and stories of how our names originated. I will not hesitate for a moment to let you know all about all the wisdom and knowledge I know. It is only right that I leave it behind with you. And I want you to listen carefully to what I have to say.

— *Ni'ysgankw'ajikskw (Lucy Williams, Nisga'a), 1982*

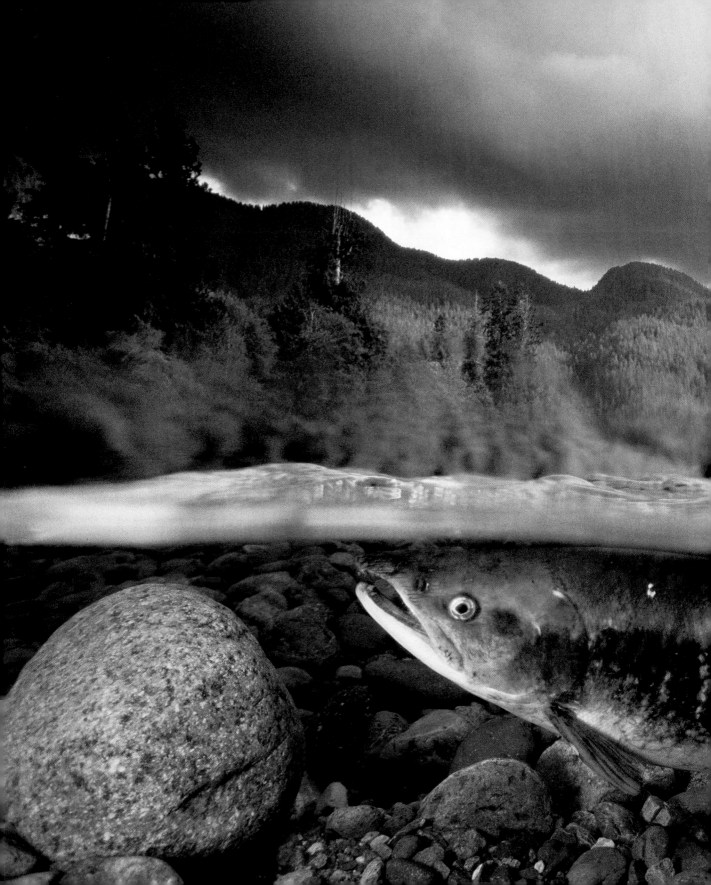

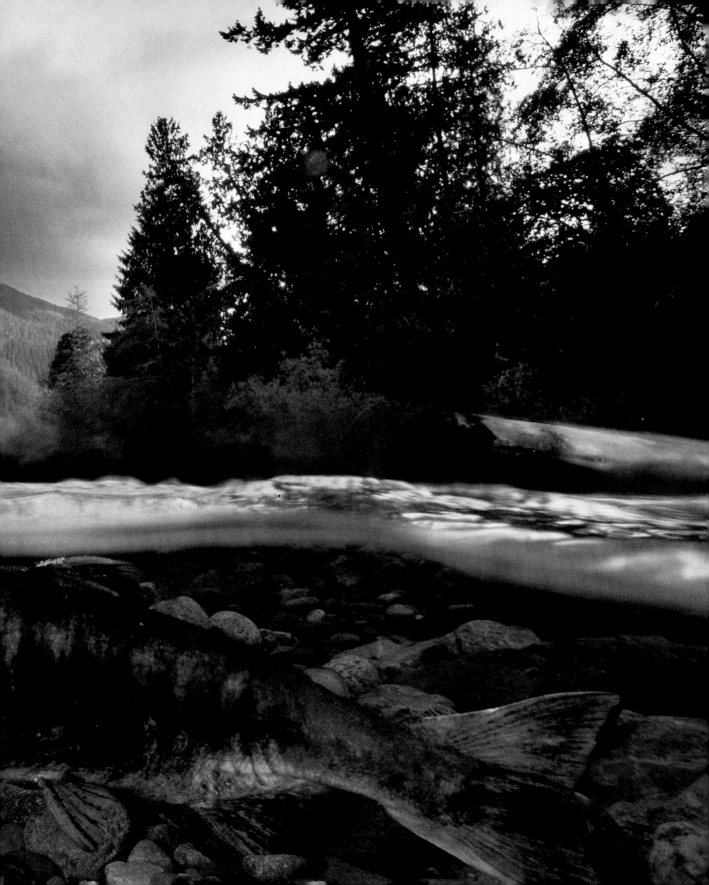

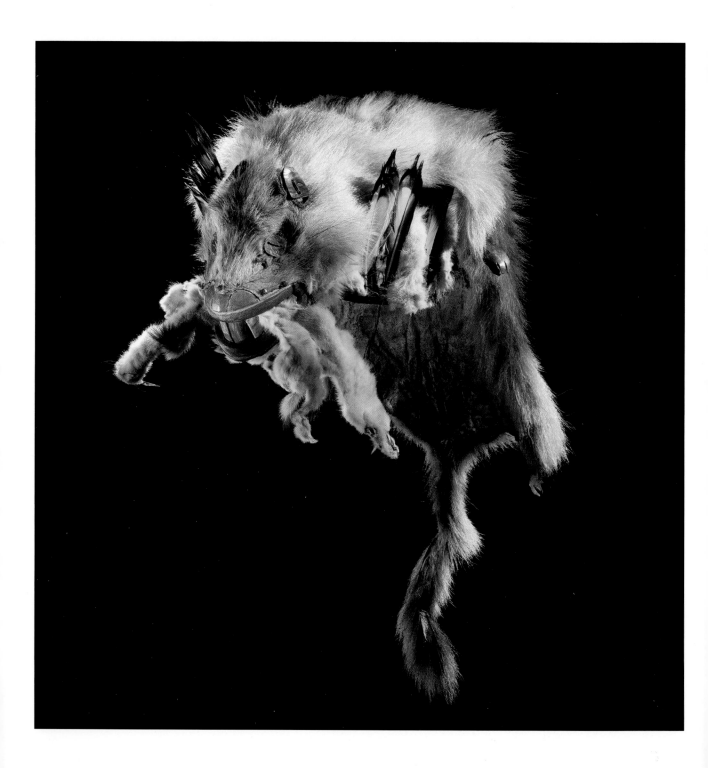

GITXSAN

⊡

Words of wisdom

Although there is no single history of the Gitxsan people, our adaaw'ax —the origin stories of our clans and houses—reach back more than 10,000 years. Through the adaaw'ax, our ganiye'etxwm and ganits'iits'm (grandfathers and grandmothers) handed down their yuuhlimaxw (philosophy or words of wisdom) and gandidils (way of life).

We believe in reincarnation of people and animals. We believe that the dead can visit this world, and that the living can enter the past. We believe that memory survives from generation to generation. Our elders remember the past because they have lived it. We know that to experience a premonition in xsi-wok (dreams and visions) is more significant than to perceive things by ordinary senses.

Gitxsan means the People of 'Ksan—the Skeena River of northern British Columbia. 'Ksan, or Xsan, has been translated River of Mist, but my father, who is ninety-two, prefers the translation River of Fog, from shian— fog—in Sim algax, "the real language," spoken by the Tsimshian and Nisga'a, as well as the Gitxsan. The Skeena begins in the high peaks of northern British

MAAS GWIIKW (ceremonial headdress) used to establish the identity of nax nok 19th c.

Albino groundhog skin, painted wood, haliotis shell, copper, yellow-wing flicker feathers

4334

HASEEX (rattle) representing

a beaver (on front)

and a frog (on back)

19th c.

Carved wood

9/7998

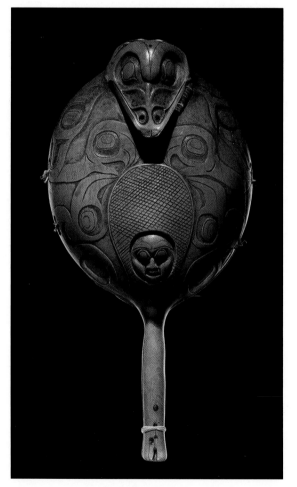

Columbia, born of clouds, glaciers, snow, and rain. As it descends to the Pacific it gains strength and volume, fed by the waters of countless tributaries.

Gitxsan territory encompasses approximately 22,000 square miles. The boundary line of our lands starts above the Kitselas Canyon, just north of the city of Terrace, and runs northwest nearly to the Portland Canal. From there it extends east across to the western edge of the Omineca Mountains, south to Babine Lake, west to the town of Hazelton, and down the Skeena River to above the Kitselas Canyon. There are approximately 10,000 Gitxsan people today. Roughly 3,500 of us live in the villages of Kispiox, Sigit'ox, Gitanmaax, Gitseguecla, Gitwangax, and Gitanyow. We all trace our origins, however, to the ancient village of Temlaham, on the south side of 'Ksan, a few miles downstream from Gitanmaax.

There are four Gitxsan clans: Lax Gibuu (Wolf), Lax See'l (Frog), Gisk'ast (Fireweed), and Lax Skiik (Eagle). The clans are divided into approximately sixty units called huwilp (houses), groups of related families under the leadership of a high chief. We attain our position in society at birth from the wilp (house) of our mother, supported by the house of our father.

NA X NO K Our grandfathers and grandmothers believed that all success came from a cosmic being who gave strength called nax nok to deserving individuals. Nax nok might be revealed in

dreams and visions, or through unusual encounters with animals or the elements. In ancient times, all chiefs sought na̱x no̱k. They fasted, purified themselves, and withdrew from society. Today, na̱x no̱k crests, performances, and songs are treasured hereditary possessions.

Well within living memory, chiefs demonstrated the power and meaning of their na̱x no̱k during feasts. Na̱x no̱k horns were blown, limx xsi-naahḻx (breath songs) were sung, and the performances began. These could be one-man or one-woman shows or could require the participation of the entire house. They could be frightening or funny; either way, they were expected to be entertaining. Na̱x no̱k were often represented by animal masks, or by masks that portray animalized humans and suggest transformation. The National Museum of the American Indian has a large owl mask, two child figures, and an owl figure collected at Kispiox in 1918. The owl is a crest of a Fireweed Clan group who live along the upper Skeena. Family members tell of a child who was taken away by a mythic white owl. When the child was recovered, the family claimed the owl as its crest symbol. The child figures, which are clothed in plucked eagle skins, were placed in different parts of the house when the play was enacted, while the owl figure was suspended from the roof timbers beneath the smoke hole.

The ethnographer William Beynon, whose mother was Tsimshian, described a performance he witnessed in 1945 by the

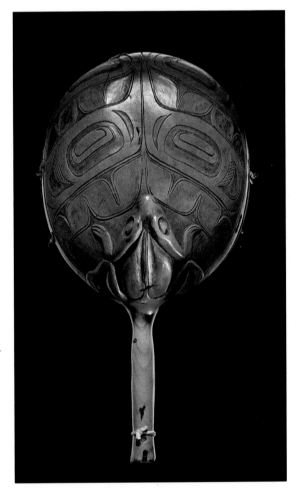

White Owl na<u>x</u> no<u>k</u> of the House of Gwáxsan. It began with the singers singing, "Where the white owl walks on the outskirts of the Great Village."

Then a group of attendants ran in, saying, "We have done something to anger the great powers, as there is a terrible monster coming this way." A figure wearing an owl mask and a feathered costume, with metal talons on his hands, grabbed each of the chiefs, who were immediately compensated for playing their part in the drama. After the White Owl had touched all the chiefs, it went to the back of the house, and a woman entered, crying, "Oh my child! Who can restore my child?" Carrying a doll in a small cradle box, she went to each of the chiefs for help, but they couldn't revive the child. Finally she went to her own chief, who took the cradle to the middle of the floor and danced and sang his song until the child appeared to struggle to stand up in the cradle box and was cured. (Beynon noted here that the child was a marionette.) Each chief who was called on for help was compensated again for taking part in the spectacle.

HAALAYT-DIM-SWANNASXW The world of the spirits played a part in the life of every Gitxsan person. Those men and women who established very powerful relationships with the

WATSX AATII'YASXW

(spirit canoe curing aid)

1870–1900

Carved and painted wood

3/5017

spirit world were called haalayt-dim-swannasxw. Haalayt in this usage means healers or shamans. Swan means to blow. The term describes the healing practice of the haalayt, who drew the illness or injury out of their patients and blew it from the house.

Haalayt-dim-swannasxw served as spiritual, emotional, and physical healers. They were also consulted as guides, problem-solvers, and sources of all sorts of information. Haalayt often disagreed about the nature of an illness and which supernatural powers should be asked to assist. Each cure had its own characteristics, but nearly all involved a trance and the removal and sending away of the disease with the aid of an aatii'yasxw—the visible symbol of the halayt's power. Aatii'yasxw might be animal skins, carved animal figures, eagle down, jointed puppets, odd-shaped rocks, or amulets of various types. Like songs of healing, animal helpers were made known to the

KSAMASIPU (Woman of Sickness)

Made by Charles Mark

ca. 1918

Red cedar, hide, metal

Lent by the Canadian Museum of
Civilization Ottawa, Canada

CMC VII-C-1156

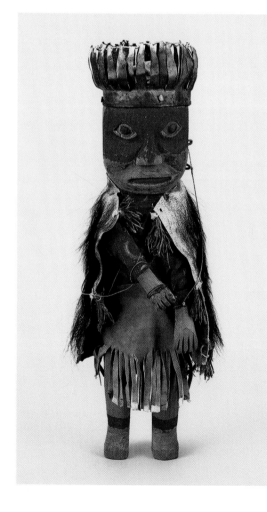

halayt in dreams. Rattles provided rhythm for songs and chants that attracted the na<u>x</u> no<u>k</u> power. The most common rattles were made of two rounded, hollowed pieces of maple lashed together with pebbles inside.

In 1920, while he was working as a research assistant to the ethnographer Marius Barbeau, Beynon recorded an interview with the halayt Isaac Danes of Gitanmaax. Danes described a series of visions he experienced as a young man and songs that came to him while he was in a trance. After a year in seclusion at his father's house, attended only by four cousins, who learned his songs, as well, Danes began training with the village haalayt. "We look at the patient and diagnose the illness," they told him. "Sometimes, it is a bad song within the patient, sometimes a nahrnohr (a spirit)." Through visions, Danes acquired several aatii'yasxw, including a canoe ('mal). "When any trouble occurred anywhere," he told Beynon, "I was able to see my canoe in visions."

One of Danes's first patients was a woman who had been treated without success by other haalayt:

So I went into her house and instructed the people there to build a fire. As I began to sing over her, many people around me were hitting sticks on boards and beating skin drums for me. My canoe came to me in a dream, and there were many people sitting in it. The canoe itself was the Otter (watserh). The woman whom I was doctoring sat with the others inside this Otter canoe. By that time,

about twenty other haalayt were present in the house. To them I explained what my vision was, and asked, "What shall I do. There the woman is sitting in the canoe, and the canoe is the Otter."

They answered, "Try to pull her out."

I told them, "Spread the fire out into two parts, and make a pathway between them." I walked up and down this path four times, while the other haalayt kept singing until they were very tired. Then I went over to the couch on which the sick woman was lying. There was a great upheaval in the singing and clapping of drums and the sticks on boards. I placed my hand on her stomach and moved round her couch, all the while trying to draw the canoe out of her. I managed to pull it up very close to the surface of her chest. I grasped it, drew it out, and put it in my own bosom. This I did.

Two days later, the woman rose out of bed; she was cured.

AATII'YASXW (small figure)

used by a halayt

19th c.

Caribou antler, iron eyes

4/1670

Danes's reputation as a halayt was established. He told Beynon that he might be paid as much as ten blankets to see a patient, depending on the wealth of the family and their anxiety over the patient's illness. If a patient died despite the halayt's efforts, the payment was returned. A halayt rarely refused a case, for then he or she might be suspected of causing the illness. In any event, Danes said, "Doctors were not known to decline any invitation to serve the people in need."

Spirit canoes like the one in Danes's vision were often implicated in outbreaks of illness. Robert Wilson, from the village of Kispiox, told Beynon about the influenza epidemic of 1918, when even those people who had

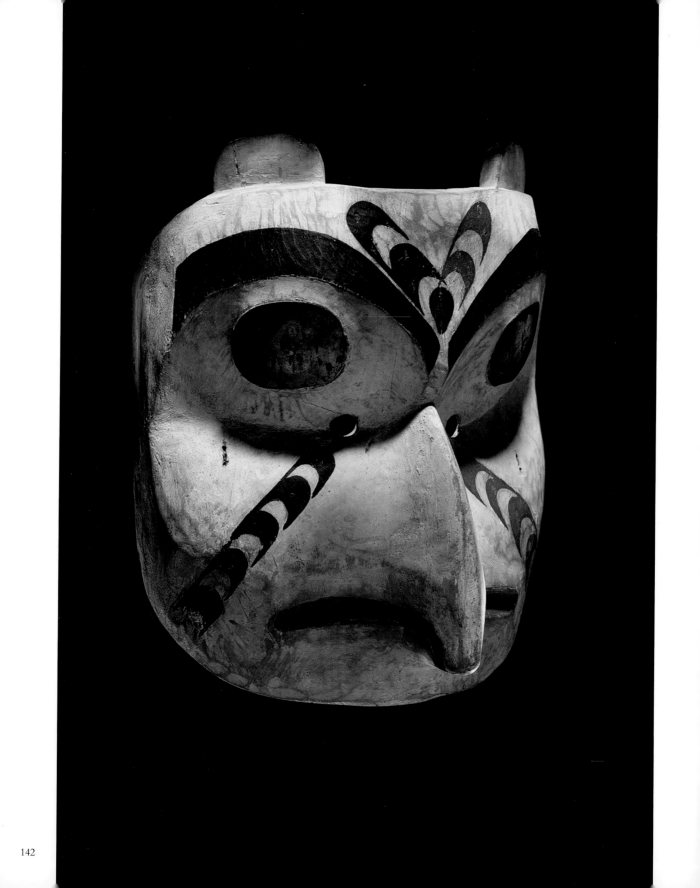

converted to Christianity turned to haalayt. Gutwinuxs, a well-known heal-er from Kispiox, was among a group of haalayt who conferred at Gitwangax to discuss the epidemic. After listening to the other haalayt, Gutwinuxs asked his nephew, Charles Mark—a member of a secret society of carvers—to make a small wooden figure of a female halayt.

When the figure was finished, Gutwinuxs joined the other haalayt at the house of a patient. He said he had consulted his helpers, but that he had to "climb by himself into the sky to see what he could do." He went to a corner of the house and entered a trance. As Gutwinuxs's assistants sang, the other haalayt covered him with bear skins. They could hear his labored breathing. After several days, the haalayt looked under the skins. Gutwinuxs was gone, and the figure of the female halayt was in his place. The haalayt replaced the bear skins and soon heard Gutwinuxs there again. The next day, they repeated the procedure. Gutwinuxs then came in through the door of this house while his assistants sang:

I am cured, because of the Woman of Sickness.
It is the Medicine-Woman of Sickness that will cure me.

Gutwinuxs said of his experience:

When I was taken into the skies, I beheld the sickness canoe in which were
several spirits, each with a harpoon. As they saw a person walking about, they

AMIILUX M K'UTK'UNUXS

(nax nok mask representing an owl)

ca. 1900

Carved and painted wood, copper

8/7996

threw their harpoon at the victim, who at once became ill. So now the Woman

of Sickness shall be my aide. The people will drink oolichan oil and devil's

club juice and burn hooclens (hellebore roots) to disinfect the houses.

Barbeau collected the figure of the Woman of Sickness for the National Museum of Man, now the Canadian Museum of Civilization.

Some of the people who assisted in research for this project, recall hearing the haalayt at work, though only a few were actually treated. The last halayt in Kispiox is believed to have died in 1960. Yet if we truly believe in reincarnation and the cyclical nature of time, then who is to say that haalayt-dim-swannasxw will never again be part of our world?

An anonymous halayt expressed this in his song:

We are an old people. We are a new people.
We are the same people, deeper than before.

—*Shirley Muldon*

How a halayt was created

One day I went up into the hills to gather wood, and it was very cold. There were many other people gathering wood as it was now winter, and it was in the hills above the village where they were. When I got to the hills, I heard strange noises at the top of the tree which I was cutting. I looked up and behold there was a large white owl sitting on the top of the big tree. Then the owl flew down and grasped my head, and flew up with me into the sky.

Well, it was then that I lost my senses, and it was then I started to dream, and this is what I dreamed: I dreamed that I was now flying way up into the sky, and here I saw a great many strange things. And I knew that it was the owl that was flying me up. . . . And then I saw before me, running about, a big white otter. It was then I became afraid, as I knew that the otter would try to influence me, as this was a power that was possessed by the white otter, to influence people. Well, then I tried to run away. I went towards the Skeena River so that I could save myself, but before I could reach the river, I fell and fainted. . . . I was very cold and it was getting dark, and behold my father came to meet me.

He had missed me, as I had been too long away, and it was nearly night. Just as soon as I got into the house I lay down and became very sick, and lay that way for one year. And my father said to me: "You will become a great halayt, that is why the White Otter came to you."

—*Isaac Danes*

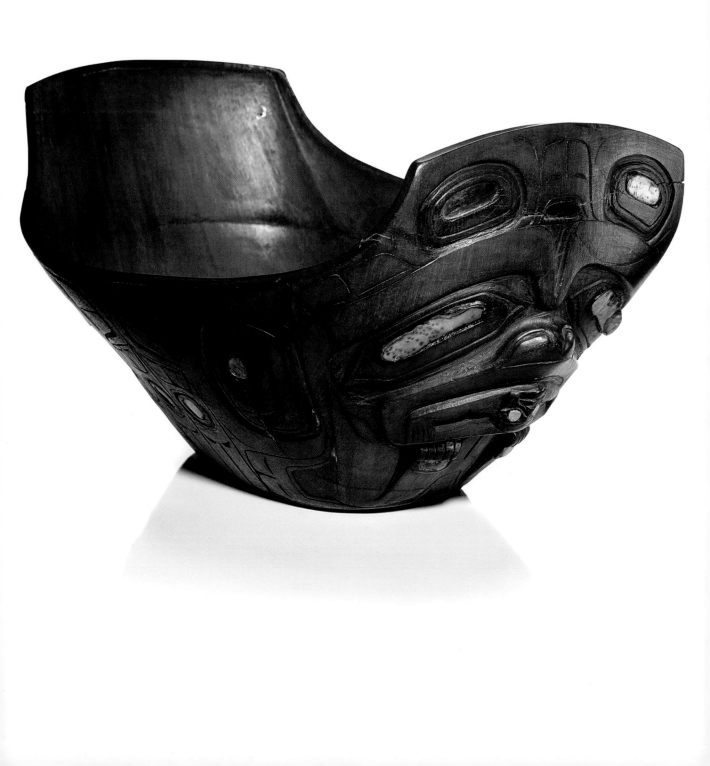

HAIDA

■

We carry on our ancestors' voices

Our territory encompasses the lands and surrounding waters of Haida Gwaii in British Columbia and the southern half of the Prince of Wales Archipelago in Alaska. This place has shaped our way of life—shaped who we are—for thousands of years. Our oral histories trace our lineages back to the time of the supernatural beginnings. Since this time, our ancestors have recorded—through our oral histories, carvings and paintings, songs and dances—the events they have witnessed, such as the Ice Age, the first tree, and the great floods. These events have collected together over time to create a rich and complex history, an intimate relationship with our lands and waters, and a way of life we would not trade for anything.

The Haida Nation is made up of two groups of people—Ravens and Eagles—each of which is divided into clans. Because we are a matrilineal society, lineage and property are passed down to the next generation through the female line. In other words, "We follow our mothers." In our culture, the concept of property transcends material wealth to include intangible

FEAST BOWL depicting a Sea Grizzly Bear crest

Before 1870

Carved mountain sheep horn with abalone shell inlay

4/411

possessions such as oral histories, songs and dances, rights, and titles. We consider these intellectual properties to be even more valuable than material possessions.

In this book, we have chosen to illustrate pieces associated with our songs, dances, and ceremonies. These objects were created by those graced with stl'inll (clever hands), or by stlanlaas (people who are good with their

hands), and offer insight into some of the rights and privileges we treasure.

Our songs and dances are more than entertainment. They figure significantly in many aspects of our culture, ranging from everyday use to formal ceremonies that honor historical events. Haida songs and dances are as old as our history. "The Singers"—two supernatural sisters who belong to the Eagle Clan—are credited with their origin. The elder sister was named, "The one out of whose mouth songs hang." The younger was called, "The one who dances about." The Singers knew birdsong, which is where Haida songs began.

Many of our ancient songs are still sung today, and new songs are being composed. Our generation feels very fortunate to sing and dance as our ancestors did. At one time, the Haida numbered well over 10,000. After 1860 epidemics reduced our numbers, and by 1890 only about a thousand Haida survived. Another blow came in 1884, when the potlatch was made illegal in an attempt to assimilate indigenous peoples. This ban, combined with the effects of colonization, silenced our way of life for many years. Fortunately for us, our naanii (grandmothers) and chinaay (grandfathers) preserved as much knowledge as they could during this time by practicing in secret. They kept our traditions alive, despite the challenges they faced.

In 1978 the village of Skidegate raised a fifty-foot pole carved by Bill Reid. In preparation for this event, Mabel Williams, an elder, got the children together and formed a group called the Skidegate Haida Dancers. Our parents had to learn how to make button blankets and buckskin dance aprons, because these types of regalia hadn't been made or used by many of our

BUTTON BLANKET with crest representing Killerwhale

1890–1920

Trade blanket, cloth, dentalia, abalone, and mother-of-pearl buttons

17/6679

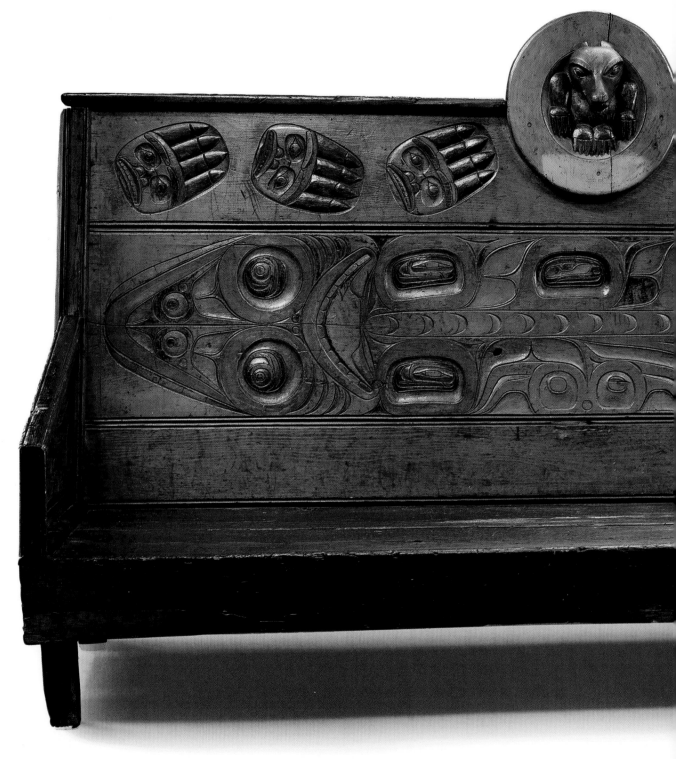

LISTENING TO OUR ANCESTORS

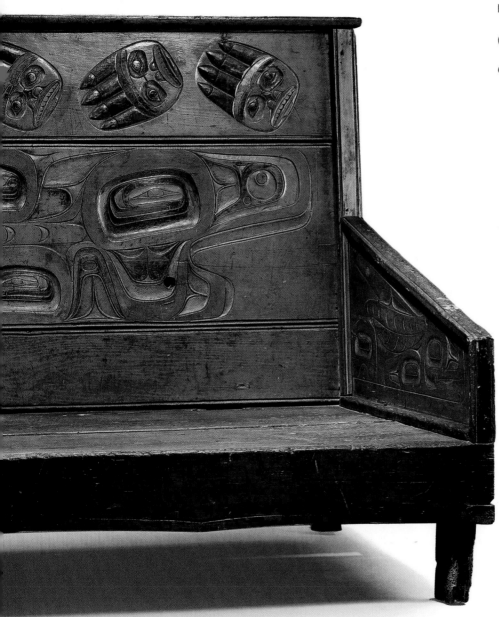

CHIEF'S SEAT with Dogfish, Grizzly Bear, and Bear Tracks crests

Made by Charles Edenshaw (ca. 1839–1920), ca. 1890

Carved wood and nails

18/2098

Following pages: Sunset on a sheltered cove near Hydaburg, Alaska

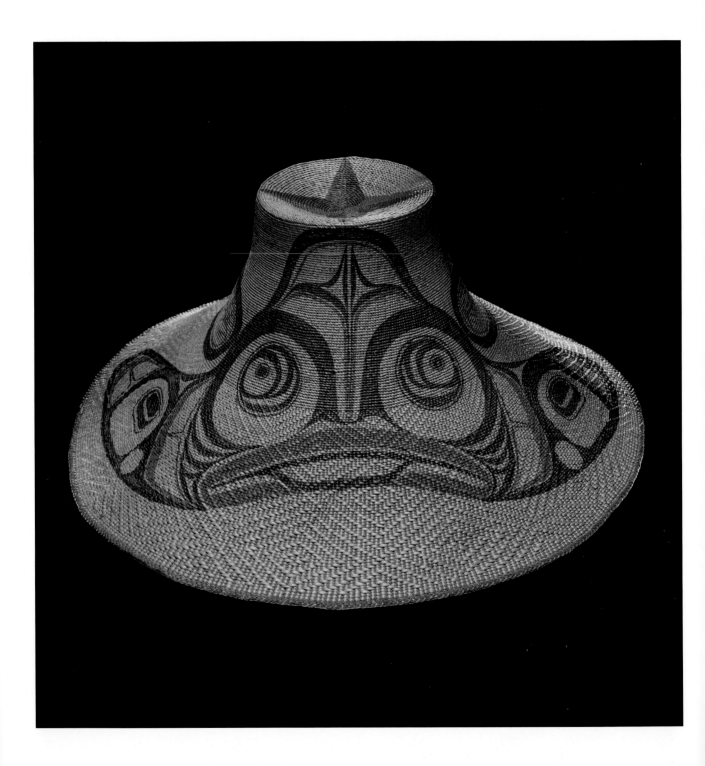

LISTENING TO OUR ANCESTORS

people for a long time. Mabel taught us songs and dances that she learned from her mother, Susan Williams, as well as some that came to her in dreams.

Susan Williams was 109 years old when she passed away in 1971. She and Henry Young, a traditional oral historian, sang Haida songs all the time. We've learned most of our ancient songs because people like Susan Williams, Henry Young, Agnes Russ, Mary Martin, Jimmy Jones, and many others maintained them for the next generation by teaching their children, and by recording the songs on reel-to-reel for their families. In Old Massett, many clan songs are still sung because elders like Amanda Edgars, Joe Weir, Florence and Robert Davidson, Sr., and Robert Ridley kept them alive. In Alaska, Selina Peratrovich, Jessie Natkong, George Nix, and Lydia Charles are credited with preserving Haida songs. Mungo Martin, a carver and singer from the Kwakwaka'wakw, also knew some Haida songs and preserved them on tape. His family must have received the songs through a potlatch.

A song is one of the most valuable possessions we can own, and the use of our songs is fiercely guarded. Through the potlatch and other formal exchanges, we've acquired some songs from other nations, such as the Tsimshian, and in turn, some of our songs now belong to other nations. Most songs are owned by individuals or clans and can only be used by their owners or appointed singers, although some songs can be used by all Haida. Robert Davidson and Vern Williams are among our contemporary composers who have created many wonderful songs and given them to all Haida to use. If you are given a song, it is something to be cherished.

HAT WITH CREST

representing a Dogfish

Made by Isabella Edenshaw

(kwii.aang, 1866–1926)

Painted by Charles Edenshaw,

ca. 1890

Spruce root fiber in Dragonfly

weave

9/8015

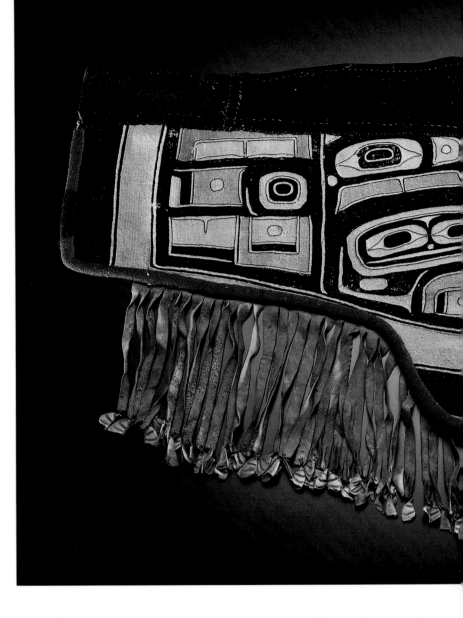

DANCE APRON made from pieces of a Chilkat blanket that represented a diving whale

Before 1870

Mountain goat wool, yellow cedar bark, cloth, leather, puffin beaks

16/2768

When we are teaching ourselves a song from an old recording, we take it to our elders. They translate it for us, and make us sing it over and over again until we get it right. Our elders are very particular, which is a good thing as it maintains the integrity of our songs and our language. The Haida language is a completely different way of thinking, so it's very important that our elders help us learn or compose songs.

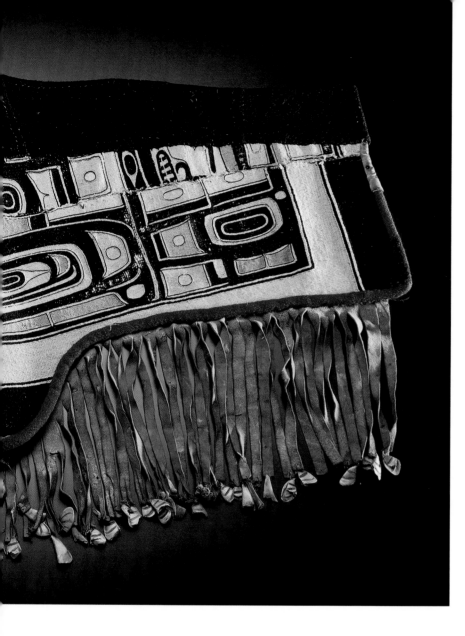

The elders tell us the history and appropriate use of the song—who owns it, who has the right to sing it. If there's a song we really love that hasn't been sung in many years, we ask the owners of the song if we can learn it and sing it. "The Grizzly Bear Said He'd Kiss an Eagle" is a fun song. It is about a Raven man who tried to kiss an Eagle woman and she pushed him away. When the elders practice this song, there is a lot of fun and joking.

When we sing and dance for our elders, their eyes light up and they tap their canes, and even the quietest elder sings along with great strength. There is nothing better than hearing the old people sing.

Most of our musical instruments—drums, clappers, and rattles—provide rhythm to accompany our songs. The rattle shown here represents a raven with a woman on its back. It is played by gently swinging it back and forth in your arms, and it makes a beautiful swishing sound.

Our elders help us with our dances, too. Hazel Stevens, who lived to be 102, gave the young people many pointers, sharing information on traditional dance moves she learned when she was young. She said they used to have to wear towels as dance blankets when she was little, because our culture was outlawed.

The button blanket shown on page 148 represents a split Killerwhale, a crest of the Raven Clan. When one of us walks into a potlatch, people know what clan we belong to by the crest design on our regalia. Some Haida say they notice a person's clan before they recognize his or her face.

During dances, people display these crests on their button blankets with pride and great style. The hosts usually arrange a dance by their own clan, where clan songs and dances are performed. They may invite other groups to dance, as well.

RATTLE

in the

form of a

raven with a

woman on its

back

ca. 1875

Carved and painted

wood

15/6845

At most feasts, there is a chance for everyone to join in, so it is common to see guests arrive carrying their regalia and drums.

There are not too many old button blankets left in our communities. Seeing this blanket in the museum's collection, putting it on, and smelling the smoke in it was a very emotional moment. It probably hadn't been worn by a Haida in a hundred years. Today, most people own at least one blanket or some other form of regalia such as this stunning dance tunic. It is huge. It must have been a very big man who wore it. The Beaver crest, which is outlined with dentalium and abalone shell, belongs to the Eagle Clan.

It is customary to receive a button blanket at different milestones in life. Nika's daughter, Gid Ḵuuyas, got her first blanket when she was four weeks old. She was given her name and presented with her blanket in front of guests at Chief Gaahlaay's 100th birthday potlatch in March 2005. When we get new regalia, it must be danced at a formal event to bring it into being.

Like our songs, the performance of Haida dance has protocols, rules, and standards. The best dancers have been trained from a young age, but there are also dances that everyone can participate in: the men's dance, where men prove they are men! The women's dance, where a woman shows her gracefulness and stature. The clan dance, where, when our clan is called, we get up and dance to show who we are, where we come from. Lucille's little girl, Amelia, was one of five people who got up to dance in honor of her Yaghulaanas father at a feast. When she teaches her

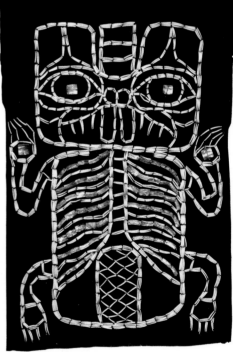

HAIDA TUNIC depicting a Beaver

Late 19th to early 20th c.

Cloth, dentalium, shell, haliotis shell

14/960

grandchildren our songs and dances, we hope that day will be one of the things she remembers.

We've been lucky to grow up witnessing powerful Haida songs and dances that can raise the hair on the back of your neck or make a lump in your throat. For us, these songs bring out emotions that nothing else in the world can. People have different tastes in music, but it is hard to meet someone who isn't moved by a Haida song, even people who don't know what the words mean.

We sing during potlatches, feasts, and other ceremonies. We have canoe songs, gambling songs, love songs, mourning songs, war songs, lullabies, and songs used for medicine. We sing in order to pay respect to that which provides for us. There are songs to help bring the salmon home, to coax the halibut to bite a hook, to keep berry pickers safe. Some people take more interest in singing and dancing than others, but all Haidas probably know at least a ga taa sralangee, a call-to-supper song, from attending potlatches.

We owe our ability to sing and dance to our ancestors, who made sure our traditions continued on. Today, songs grace every aspect of our lives. Wearing our regalia, singing our songs, and performing our dances grounds us and fulfills us. It is our responsibility to pass our culture on stronger than ever. We are carrying on our ancestors' voices.

—*Lucille Bell, Nika Collison, and Jolene Edenshaw*

Grizzly Bear tried to kiss an Eagle

Wait, this is what they said,
A grizzly bear said he would kiss an eagle,
But she did not want him

Yaay 7u 7aa 7ii yaa 7aa laa
Yaay 7u 7aa 7ii yaa 7aa laa
Yaay 7u 7aa 7i yaa 7aa lo7

K'waay tligw naan saa-7waan
Nang cuu-jaa nang ruu-daa
Skintl'aa saa-ngaa-nuu
'laa-gii 'lii gwaa-waa-yan

yaay 7uu 7aa 7ii yaa 7aa laa
Yaay 7u 7aa 7ii yaa 7aa lo7

K'waay tliiigw nan saaw-7waan
Nang cuu-jaa nang ruu-daa
Skintl'aa saa-ngaa-nuu
'laa-gii 'lii gwaa-7waa-yaan

—From a recording of
Robert Davidson, Sr. (Haida)
Old Masset, 1969

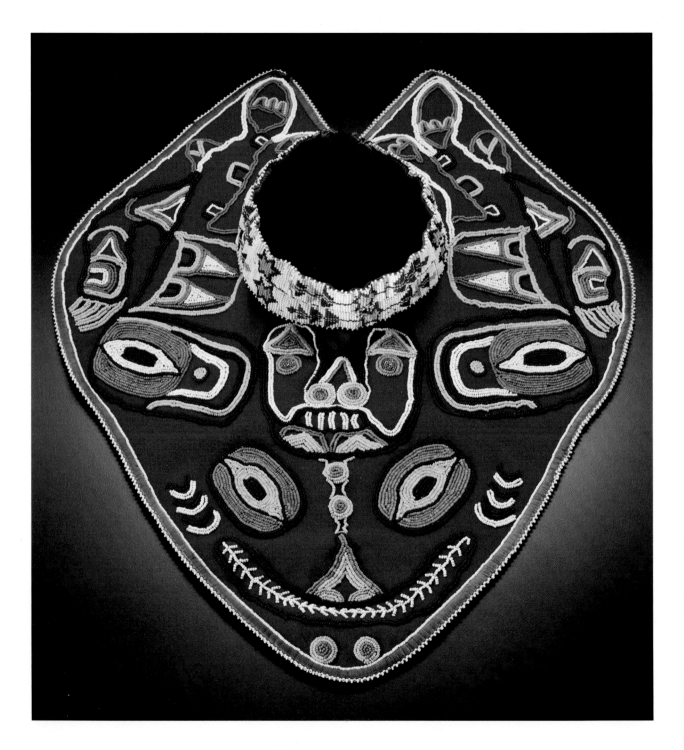

TLINGIT

⊡

Things we will remember

My great-grandfather was ninety-eight when he died. He used to tell me that our ancestors had a lot of war over our territory in the past. Then someone said, "We have to stop. Why do we want to conquer someone else?" My grandfather said that this statement came from the Chilkat River in Klukwan, where everything began that was right for humankind. But long before that time, the Tsimshian came north, or so legend has it, and attacked our family. My great-grandfather said he thought it was a small group of Tsimshian people who went on raids like that. Then one time they camped by a cliff, where the sand went up into a cavern. And an old shaman built a replica of the cliff, and he crushed it. And that's what happened to them; they are still sitting beneath that cliff. Archaeologists have climbed down there and found that their canoes are there, their firepit is there, and the bones are still sitting up. That got the raiding to stop.

My great-grandfather taught me to see the Native people of Alaska and the Northwest Coast as a forest on a mountainside, a group of individual trees strengthened by our interlocking roots.

DANCE COLLAR

ca. 1900

Beaded cloth and ribbon

21/859

GUK'ÁT (earrings)

19th c.

Abalone shell

9/9855

HELMET

1790–1820

Wood covered with walrus

or sea lion hide

8/1886

KAGÍS KAGEIT (armor)

Early 19th c.

Walrus hide and Chinese coins

16/8287

The history of the Tlingit people goes back 10,000 years and more. Our home lies along the panhandle of southeastern Alaska and the islands nearby. There are also Tlingit villages across the mountains, but we gave up our rights to fish the upper Taku and Stikine rivers after the U.S.–Canadian border was drawn in 1906. It's difficult to say how many Tlingit people there are. The Sealaska Corporation, established by the Native Claims Settlement Act of 1971 to manage the economic resources of Alaska's Tlingit, Haida, and Tsimshian people, started out with 16,000 adult shareholders. The Central Council of the Tlingit and Haida tribes of Alaska uses the figure 26,000.

The old people would say that everything shown here tells a story, even something as small as an abalone earring. One time a man from the Chilkat area wanted to go and visit his relatives, my grandfather's people, at the head of the Nass River. So he gathered local delicacies to give to people down in Canada. When I think of this story, I wonder how long it took him to row from Chilkat Inlet through the Lynn Canal and down the coast, then up the Portland Inlet to the mouth of the Nass. When he arrived, he would have camped a little way outside the village. In the morning, when the sun hit the water, he would have rowed up to the narrow head of the bay. He would have started beating his drum and singing as he approached the village. Maybe he was standing in the bow of his canoe. And he must have hung an earring over his ear. The Tlingit name for these is ghun-ha, abalone or abalone shell. When the sun hits it, it sparkles.

When they heard the drum, people came out of their houses. People

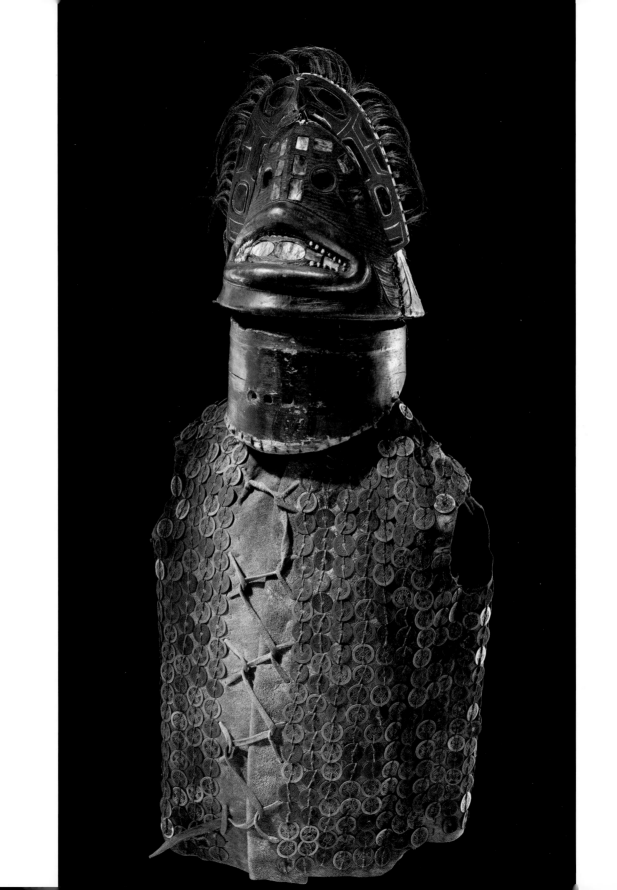

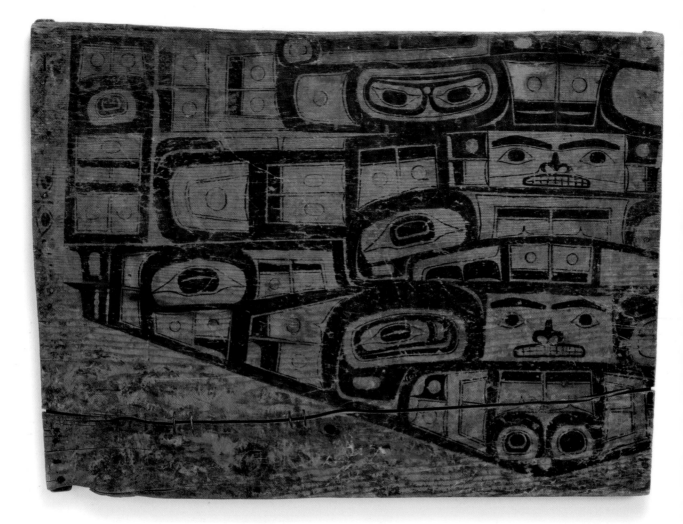

lived where there was a nice beach so canoes could be brought up on shore without any rocks around. When he came near the shore, the village did a ceremonial thing we did all up and down the coast: they asked, "Who are you?" And he hollered back. And they said, "Where are you from?" And he said that he came from up north. They let him land and they helped him carry the canoe up the beach.

He stayed there a long time. They had a great party, and he gave his gifts

Preceding pages: Sawyer Glacier,

above the old Tlingit village

of Sumdum, Alaska

LISTENING TO OUR ANCESTORS

away, but he kept the earring. Finally, when it was time to leave, he told them, "I've got to go home." Maybe the southeast wind was starting to blow so that he could put a sail on his canoe and not have to row against the weather. Something made him decide it was time to go home. So the village people said, "We'll have another party before you leave." They had a great party, and they filled his canoe with gifts. There is always a balance to the things we do in our culture. If somebody gives you something, you have to figure out a way to give something back. And so they filled his canoe with gifts. The head of the clan really liked that abalone earring, and the guest knew that. So at the final dance, when he finished dancing, the Chilkat man called the chief out, and he hung the earring on his ear. The earring stayed with the clan chief there.

Many years might have gone by, and the head of the clan decided he wanted to go up north and visit his relatives. But something he didn't know was that people up there were angry at people down south. No one understood why, but at the end of his visit, when he was getting ready to leave the clan house in Chilkat and go back home, a child came to him and said, "They are going to kill you as soon as you walk out the door."

NAAXEIN SAKAI YAHAAYI

(Chilkat blanket pattern board)

1860–1890

Painted wood

2/9130

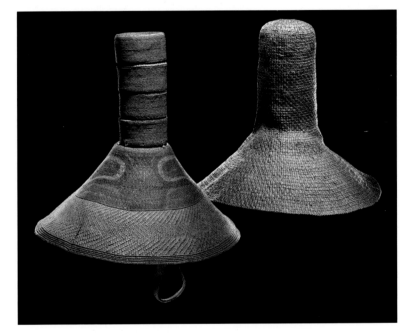

SHADAAK'OOX

1850–1880

Twined and painted spruce root

hat; woven cedar bark rain-cover

9/8087

XOOTS AWCH (Brown Bear

Clan hat), belonging to

the Taqwayta family

ca. 1860

Carved and painted wood,

sea lion whiskers

2/9138

And the chief thought, "Now, what happened here?" My grandfather says maybe his life went around in front of him like a movie as he tried to recapture what he had done wrong. He finally came to the conclusion that he hadn't done anything wrong, so he said, "Well, maybe this is my destiny." At the final dance, he was going to dance out the door to meet his fate. And at that final feast, he held his hand under his spoon and did not let a drop of anything hit the floor, because it was his last meal and he wanted to taste it all.

Sometimes when the grandparents tell this story, they stop right here and they don't tell the rest of it. Then it becomes a story about our appreciating the food we are given. But the whole story says that the chief put the earring on. And as he danced, all the others recognized the earring and knew that it had come as a gift from them. And they immediately sent word to the people outside to come in and not to kill him. He didn't ask what it had been about. He only thought that his life had been spared and he attributed it to that earring. So when he came home and they had a great party, he told this story. In the big tribal house, he told them to put a peg in the wall at the head of the house, and he hung the earring on the peg. And every time the earring went to a party, when it came back they put up a higher peg. You can see how many parties that earring has been to. The idea of raising something up, calling attention to its value, is very important to us.

I heard my great-grandfather tell that story many times. His was a generation of orators. They never spoke directly about anything. They liked to talk in riddles. Our oldest crests were Raven and Wolf, later changed to Eagle, and each

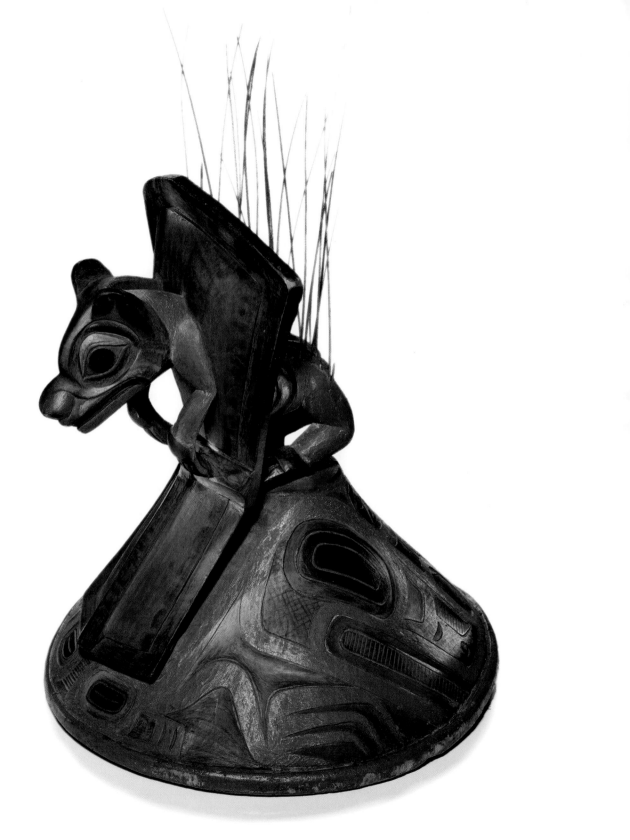

TLINGIT

JÁNWU SHEIDÍ SHÁL

(feast ladle)

1870–1900

Shaped and carved mountain
sheep horn

21/4492

of us belongs to one or the other side of the nation through our mother, as well as to her clan. A favorite thing was for the Eagles or Ravens to think that people of the other side weren't very brilliant if they couldn't answer the riddles. They'd test the intelligence of the other side, and sometimes they'd thank them for being intelligent. Nowadays we don't do that. In the past, when someone was telling a story, he'd stop and not finish it, and the opposite side would thank him for telling the story. Now when I tell a story, I finish it, because otherwise people won't have the benefit of hearing the whole thing, but I remind them that I'm not following the protocol of the people of yesterday.

I look at the Tlingit collection at the museum and admire how beautiful the things are, and how skillfully they were made. To keep the pattern of a Chilkat blanket perfectly symmetrical when the weaver probably only had sticks to mark her place—none of us know how the women did that. But even more important is the respect and ceremony behind the objects, and what they mean. Most of the things chosen for this chapter are atoo, treasures, or kooeex-no-at, clothing to be worn at parties. The first time they were brought out at a potlatch, or party, the host's clan put money out for the dedication, and the money was distributed to the guests.

The Brown Bear hat tells the story of my grandmother's wedding, when she walked on copper shields, one of the greatest symbols of wealth along the Northwest Coast. When the hat was dedicated, a hundred years ago, the

families of the Bear Clan put money out for it, and someone from the clan danced with it, and forever after people knew that it was valuable property. The events it records, the party where it was dedicated, the money that was put on it, and the ceremony all bring it value. When the missionaries and the government tried to stop the potlatch, they said, "No more parties! You are throwing money back and forth too much. You are making poor people out of wealthy people." But it's not about throwing money around, my great-grandmother said. It's about saying thank you. People come to warm your heart and your spirit. Nowadays, we write down who is there, but my grandmother and great-grandmother simply remembered who came. They remembered greeting each canoe.

For the party he hosted in 1904, my great-grandfather's uncle, Charlie Skeek, went out and dried 1,500 fish. He told his people that he didn't want his party to cost them money, so he dried all that fish. Once the party started, he wanted the guests to be fed well. His family built a building and stacked it to the ceiling with salmon.

One nephew said that at any given hour, he would get up, and the old man was up in the ceiling of the smokehouse, walking among the fish to make sure that they were all drying evenly.

XOOTS SIX' (Brown Bear bowl)
1840–1880
Carved wood inlaid with
opercula shells
9/7990

TEEL (moccasins)

1890–1920

Deerhide, squirrel fur, and beads

16/8353

SHIRT WORN BY

A NOBLEWOMAN

ca. 1900

Beaded cloth

21/3784

Charlie Skeek lived in the village of Kake, but guests came from as far as Juneau. I don't know how they knew what date to show up. No one had a telephone. The hosts must have told them a year in advance, "When the year starts to turn chilly, set out then."

They probably had someone in Kake watching for the canoes, to tell the guests that they would be staying at the summer camp, on an island across from the village. All night long, people could hear the guests practicing on the beach. They could hear the drum resonating across a quarter mile of ocean. At the same time the people of Kake were practicing their welcome dance.

In the morning the guests on the island brought out planking to put across their canoes and make a big dance platform. And the guests danced and sang on this raft while a few people paddled them across. The hosts began the welcoming exchange—"Who are you?" "Wooshkitan. We have been invited to your party"— and started their welcome dance. They had carved a brown bear, four or five feet tall—it was life-size—and they had it standing on a kind of skid so that they could raise it up out of the water. They had buried a rope in the sand, and many men stood behind one of the dunes. When the drum hit a certain beat, they would raise the brown bear up one foot, until the bear was completely out of the water. Then the whole village came out of the grass to dance while the brown bear welcomed the people of the Wooshkitan.

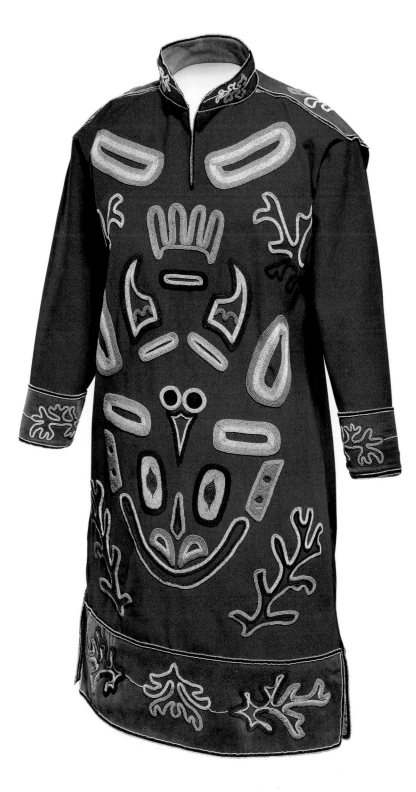

My great-grandfather's mother bought her family's Chilkat blanket for that potlatch. And every time we see it, we think of that party and the people who took part in it.

By conserving these objects, the museum has honored our culture and raised it up. When these things go back to Alaska for everyone to see, it will be as though we hung them on the wall like the abalone earring in the story. They are going to shimmer in our minds for a long time.

— Clarence Jackson

DRUM

19th c.

Painted wood

19/9099

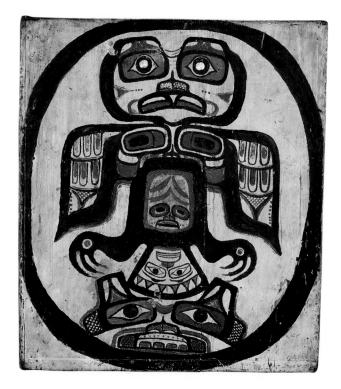

LISTENING TO OUR ANCESTORS

The trees

are coated with snow

as if robed in Chilkat blankets,

the wind—

a song,

as if led by a drumbeat.

The fringe of bottom branches

swirls around the trunks,

keeping time to the beat.

A wind rattle

blowing through the branches

accompanies the drum.

This could be

a clan-house steward

with his grandchildren

making their debut,

brought out

to be recognized

and vested as descendants.

—*Nora Marks Dauenhauer (Tlingit)*

EPILOGUE

Learning to see from within

George Gustav Heye (left),

Mrs. R. C. Dravey, and

E. S. Robinson, holding Nuxalk

carvings. Vancouver, British

Columbia.

Photo by T. P. O. Menzies.

36887

Ever since the first ships from Russia and Spain, Boston and Bristol sailed into the sheltered waters of the Northwest Coast more than 200 years ago, objects made by the Native people of the area have been carried all over the world. Acquired as what were known in the eighteenth century as "artificial curiosities," thousands of carved bowls and boxes; ceremonial masks and headgear; painted hide tunics; blankets twined of cedar bark and mountain goat hair; ornaments of copper, bone, and abalone shell; artfully constructed baskets, hats, and halibut hooks; exquisitely crafted ivory and stone charms; examples of whaling gear; and giant totem poles were collected by explorers, whalers, fur traders, government officials, missionaries, and tourists. George Gustav Heye (1874–1957), the wealthy New Yorker who founded the Museum of the American Indian/Heye Foundation, now the Smithsonian's National Museum of the American Indian, was by no means the earliest collector in the area, but he was among the most prodigious. Heye's Northwest Coast collection is one of the largest and most comprehensive in any museum, consisting of more than 27,000 objects. (Because some pieces are grouped together, these objects are identified by some 14,000 catalogue numbers, most of which were inked onto the objects in Heye's own hand.)

Heye began building his collection in 1897, when he bought a hide shirt from a Navajo woman in Kingman, Arizona. As early as 1904, he purchased a Tlingit shaman's rattle from a Los Angeles curio dealer named Bernard Whalen. Heye's notes show that Whalen acquired the rattle in 1879. By 1905 Heye had

begun a long relationship with Lt. G. T. Emmons (1852–1945), a U.S. Navy officer who spent most of his long life acquiring objects from the North Pacific and selling them to museums large and small. More than 8,000 pieces in the Heye collection are credited to Emmons, many of them objects of great historical importance and high aesthetic quality. Among them is a collection of nephrite and jadeite tools and ornaments, which were published by the Museum of the American Indian/Heye Foundation in 1923 in *Jade in British Columbia and Alaska, and Its Use by the Natives*, volume 35 in the museum's series *Indian Notes and Monographs*.

Other dealers also provided Heye with materials. In New York City he patronized F. M. Covert and Julius Carlebach. In Seattle, J. D. Standley's Ye Olde Curiosity Shop was a favorite; the shop is still in business today. In Victoria, British Columbia, C. Frederick Landsberg and H. Stadhagen were sources for material. Heye also visited dealers in Paris and London; he made more than fifty voyages to Europe during his long life, not ceasing until the advent of the Second World War.

Dealers were only one of Heye's many sources for material. He also made exchanges with other museums. At that time, museums often swapped surplus or unwanted objects for pieces curators considered more desirable. The rare Nuu-chah-nulth whaler's hat shown on pages 52 and 53 was acquired by a Capt. James Magee in 1794 and given to the Peabody Museum at Harvard; it came into Heye's collection through an exchange with the Peabody. Other pieces of the collection were acquired in trades with the University Museum in Philadelphia, where Heye began his museum career as a trustee before he left to build his own institution in New York. Several Haida and Tlingit pieces collected by James Swan in the 1870s and 1880s for the U. S. National Museum

(now the Smithsonian National Museum of Natural History) made their way into Heye's collection early in the twentieth century.

When he established his Museum of the American Indian/Heye Foundation in 1916, Heye began tapping another source for objects. He hired anthropologists who were at the beginning of their careers to collect for him while doing their own fieldwork. Two of the most successful of these collectors were Leo J. Frachtenberg (1883–1930), who shortly after World War I worked for two years with the Makah, Quileute, and Quinault communities of Washington State, and Thomas T. Waterman (1886–1936), who spent from 1919 to 1922 with the Coast Salish people of Puget Sound. Each researcher acquired large and well-documented collections of baskets, fishing materials, and other household objects, as well as some ceremonial pieces. Waterman described the results of his mission for Heye among the Coast Salish in *Notes on the Ethnology of the Indians of Puget Sound:* "Naturally the collection made in the year 1920 is anything but exhaustive. A good deal of material is to be found in the region even yet, though it is somewhat scattered." Waterman encouraged others to follow him, writing, "The memory of old times certainly cannot persist indefinitely." Methodist missionary Thomas Crosby (1840–1914) was the source of Gitxsan, Tsimshian, and some Haida pieces acquired between 1880 and 1900. A large collection of objects from the Vancouver Island area, which had been acquired through various questionable methods by Capt. D. F. Tozier, an officer of the U.S. Revenue Cutter Service, was purchased from a warehouse in Seattle.

In 1922, while on one of his trips to British Columbia, George Heye came across more than 400 Kwakw<u>a</u>k<u>a</u>'wakw ceremonial masks, rattles, and other regalia that had been surrendered to the Royal Canadian Mounted Police following Dan Cranmer's potlatch. Heye quickly purchased thirty-five pieces for $291—a tiny fraction of what these things were worth to their Kwakw<u>a</u>k<u>a</u>'wakw owners. A few years later Heye acquired another eleven pieces from the wife of the R.C.M.P. officer who had been instrumental in prosecuting the potlatch defendants. After the creation of the National

Museum of the American Indian in 1989, most of these pieces were returned to the Kwakwa̱ka'wakw, who had actively sought their repatriation. They are now part of the collections of the U'mista Cultural Society in Alert Bay and the Kwagiulth Museum and Cultural Centre in Cape Mudge.

Heye was still collecting Northwest Coast objects in the 1950s, shortly before his death. The collection has continued to grow through gifts and purchases in the decades since. The museum is also beginning to acquire important pieces from many of the exciting and innovative artists working today.

Over the past two centuries, the ways in which outsiders view objects from the Northwest Coast have undergone a series of transformations. In the eighteenth century these things—indeed, all objects of material culture made by indigenous people—were thought of as curios or exotic travel souvenirs, not as valuable to the advancement of knowledge as plant or animal specimens were. In the nineteenth century, ethnographic collections were considered to be useful evidence of "primitive" technology, illustrations of pagan (that is, unchristian) beliefs, and testimony to the lives of people who were becoming extinct. At the 1876 Centennial Exposition in Philadelphia, totem poles and other carvings were likened to "hideous monsters . . . painted in crude colors." The natural history museums that were being created in such cities as Berlin, London, Montreal, and New York placed the pieces on display as scientific specimens, sometimes arranged in rows for comparison, sometimes placed in life-size dioramas intended to show what were seen as pre-civilized ways of living.

By the early twentieth century aesthetic tastes were changing, as were the ways non-Natives thought about Native objects. The same pieces that had been seen first as strange, crude exemplars of an exotic way of life, and then as scientific specimens, were now being viewed as art. The movement began in France at the same time George Heye was commissioning Leo Frachtenberg and T. T. Waterman to collect "all objects illustrating material culture and ceremonialism which were still to be found in the hands of the Indians." In Paris, Pablo Picasso, Modigliani, Henri Matisse, and others found inspiration in the tribal art on view at the Musée d'Ethnographie, powerful pieces expatriated

from colonial Africa. In 1927 a show of Canadian modernist paintings curated by Eric Brown, director of the National Gallery of Canada, opened at the Jeu de Paume in Paris before being shown in Ottawa; it included a selection of carvings and textiles by Native artists of the Northwest Coast.

In 1931 Oliver LaFarge and John Sloan organized an *Exposition of Indian Tribal Arts* at Grand Central Station in New York. In 1939 Rene d'Harnoncourt, later the director of New York's Museum of Modern Art, curated the first national exhibition of Native American arts. On view at the Golden Gate International Exposition in San Francisco, the exhibition featured a gallery of dramatically lighted totem poles, masks, and other objects from the Northwest Coast. In 1941, at the Museum of Modern Art, the exhibition *Indian Art of the United States* included a Haida shirt and a Coast Salish canoe model from the Heye collections, as well the Tsimshian mask shown on page 102.

The decades after the Cranmer potlatch have sometimes been called "the sleeping period" for the cultures of the Northwest Coast. In fact, during the 1920s, '30s, '40s, and '50s, Native people throughout the region were working to preserve the treasures of their material culture, as well as their languages and other traditions. Between the mid-1950s and the late 1960s, galleries and museums from the West Coast to Chicago—and the Seattle World's Fair—presented curated exhibitions that explored the aesthetic achievements of the Native cultures of the Pacific Northwest. In 1959, the communities along the upper Skeena River opened the Skeena Treasure House, leading in 1970 to the creation of 'Ksan Indian Village and the Kitanmax School of Northwest Coast Indian Art.

In many ways, the Northwest Coast "renaissance" of the 1960s and '70s represents the awakening only of a larger public within the United States and Canada to the brilliance of Northwest Coast art.

In 1984 the New York art world opened three major exhibitions of what was by that time being called "tribal art." The most prominent one, created by the Museum of Modern Art, was entitled *"Primitivism" in 20th Century Art:*

Affinity of the Tribal and the Modern. Irony had entered the cross-cultural conversation. The second tribal art exhibition, a show of Maori art from New Zealand, was on view at the American Museum of Natural History. The third, *Out of the Mists: Northwest Coast Art from the Museum of the American Indian,* shown at the IBM Gallery of Science & Art on Madison Avenue, was mounted by the Museum of the American Indian/Heye Foundation. Collectors, connoisseurs, and museum-goers had come to recognize that works by Northwest Coast carvers, painters, and weavers represent one of the great art traditions of the world, worthy of exhibition and publication as artistic masterworks, and priced accordingly in the auction market.

Recent scholarship on material culture points out that things, like people, have biographies, and that one way to understand their meanings is to follow the paths they have taken from their creation to the place they hold in our own time. The journeys objects take from the communities where they were made and used to museum collections may be short or lengthy. Their documentation may be rich with information or offer little or none, their path traced with care and accuracy or embellished with tall tales and myths. When George Heye was collecting, his goal—indeed the goal of all the collectors of the time—was to acquire a collection that was not only "complete," but also "well documented." The object collected was primary, and its documentation focused on where and by whom it was acquired, whether it was a "rare" or "early" example, whether it had actually been used or was made for sale. Field collectors usually endeavored to document the Native name for a piece and something about its cultural context (although too many objects in museum collections are simply designated as "ceremonial"). But, with some exceptions, collectors neglected to record the name of the maker and failed to ask about the stories that might reveal the cultural meanings of the object, or the songs that might have been sung and the prayers that might have been said during the process of its creation. For the collector, the tangible object was what was important. For the maker or user, the universe of meaning embedded in an object may have been so clearly understood that it did not seem to require explanation.

Or perhaps those meanings were private, personal knowledge, more valuable than the object itself. Sometimes as an object moved along the path leading to a museum, its stories stayed with it. More often those stories were left behind.

The gulf between the creator's and the collector's ways of thinking can be striking. Tlingit Chilkat dancing blankets, or robes, were admired by collectors for the fineness of the twining and the dazzling complexity of the designs—to the extent that sometimes a collector or dealer cut off the weaving's long, swaying fringe in order to display the design more prominently. But in the Tlingit language, the name for a Chilkat robe is *Naaxein,* which Emmons translated in his notes as "the fringe about the body."

To return to the carved and painted mask that opens the Tsimshian section of *Listening to Our Ancestors* (see page 102) the museum's documentation of the piece begins in 1914. Its path since then is known, but it may have been a hundred years old when George Heye purchased it from his favorite London dealer, W. O. Oldman. It is a sensitively carved image of a man whose face is painted with mysterious and beautiful designs. Naturalistic masks like this one are often referred to in the literature on Northwest Coast art as "portrait masks." We do not know the name of the artist nor any attribution beyond "Tsimshian."

The mask may have been carried to England by a sea captain or an explorer as a souvenir of his travels. Did the collector place it in a curio cabinet? Did children play with it, or try it on? Did it languish in some English attic for a generation or two? These are unknowns as well. Eventually the mask was sent to Oldman's, where George Heye snapped it up and brought it back across the ocean. It was lent to the aforementioned 1941 exhibition at New York's Museum of Modern Art. In 1973 it was on view at New York's Metropolitan Museum of Art in an exhibition entitled *Masterworks from the Museum of the American Indian,* where it was described in the exhibition catalogue as "Classic Wooden Mask; Tsimshian; Skeena River, British Columbia, circa 1800." The caption suggests that it is "possibly a portrait." In the old Heye Museum in New York, in an area packed tightly with masks, drums, carved chests, and

headdresses, it was displayed in an exhibition case labeled, "Masterpieces of Northwest Coast Art." Sometime in the 1970s its image adorned the front cover of a phonograph record jacket produced by a Canadian rock band called Chilliwack. In 1982, on a quiet Sunday afternoon, it was stolen from its exhibit case together with three other masks. Newspaper accounts described it as "an 18th century stylized mask of a human face that is appraised at more than $500,000." (Eventually all four masks were recovered.)

When the exhibition *Creation's Journey: Native American Identity and Belief* opened at the inauguration of the George Gustav Heye Center of the National Museum of the American Indian in New York in 1994, the Tsimshian mask was displayed at the entrance along with two other iconic objects from the Heye collection under the heading, "What is a Masterwork?" Label text stated that "this is one of the most famous examples of Northwest Coast mask-making. . . . The visual impact of the face transcends any other use of the mask."

Now this "famous" mask appears again, in this book. The Tsimshian curators for *Listening to Our Ancestors* acknowledge the fact that the mask is an artistic masterpiece, and they selected it for their essay "in part because of its great artistry." They then go on to add, "But the mask also speaks to our understanding of our relationship to the spirit world. The eyes of the mask look to see the spirits that lie behind material reality. Seeing and hearing are important to our culture. . . . Seeing and hearing properly lead to understanding and wisdom."

Readers will see the mask, as they have for half a century, as comparable with great art works in the Western tradition. But the Tsimshian writers in *Listening to Our Ancestors* see it from the inside looking out, as an instrument that empowers the wearer to see the spirits that fill the Tsimshian vision of the world. The unnamed man who created the mask has found immortality in the museum as a great artist. The ancient presences the mask's wearer saw are still known in the land where he danced.

—*Mary Jane Lenz*

NOTES
AND REFERENCES

LANGUAGE The North Pacific Coast is one of the most diverse linguistic regions in North America. The languages touched upon in this book use phonemes (meaningful sounds) not easily represented with the 26-character Roman alphabet. A nation's official Web site, or the Web site of its cultural center, is often a good place to look for more information about its language, including, in many case, interactive guides to pronunciation.

COAST SALISH In 1854, the Suquamish Chief Seattle gave a speech in reply to the U.S. proposal to buy Native lands around Puget Sound. Working from notes he took at the time, Dr. Henry A. Smith published a translation of Chief Seattle's oratory in the *Seattle Sunday Star* on Oct. 29, 1887. The modern version by poet William Arrowsmith printed here is preferred by the Suquamish Tribe: www.suquamish.nsn.us.

Suquamish Museum, Port Washington Indian Reservation, Washington: www.suquamish.nsn.us/museum/index.html.

MAKAH The enrolled population of the Makah Tribe is approximately 2,360, of whom approximately 1,750 live on or near the Makah Indian Reservation. The Makah Nation hosts the Makah Days Celebration, open to the public, every August: www.makah.com/home.htm.

The quotation by Hildred Ides appears in *Voices of a Thousand People: The Makah Cultural and Research Center,* by Patricia Pierce Erickson (Lincoln: University of Nebraska, 2002), 80.

Harold Ides is quoted in *Tradition and Change on the Northwest Coast: The Makah, Nuu-chah-nulth, Southern Kwakiutl, and Nuxalk,* by Ruth Kirk (Seattle: University of Washington, 1986), 136.

Observations by Tom Parker and Helen Peterson are from oral histories recorded by the Makah Cultural and Research Center.

"The Song of Seven Daylights" appears in *Singing the Songs of My Ancestors: The Life and Music of Helma Swan, Makah Elder,* by Linda Goodman and Helma Swan (Norman: University of Oklahoma, 2003), 205–07.

For more on Ozette, see "A Makah Village in 1491: Ozette," by Maria Parker Pascua, in *National Geographic,* vol. 180, no. 4 (October 1991), 38–53.

See also The Makah Cultural and Research Center, Neah Bay, Washington: www.makah.com/mcrchome.htm, and "Makah: Living in Harmony," by Greig Arnold, in *Stories of the People: Native American Voices* (Washington: National Museum of the American Indian, 1997), 42–53.

NUU-CHAH-NULTH Each Nuu-chah-nulth nation includes several chiefly families, and most include what were once separate local groups. Our nations are divided into three regions: the Southern Region (Ditidaht, Huu-ay-aht, Hupacasath, Tseshaht, and Uchucklesaht), Central Region (Ahousaht, Hesquiaht, Tla-o-qui-aht, Toquaht, and Ucluelet), and Northern Region (Ehattesaht, Kyuquot/Cheklesahht, Mowachat/Muchalaht, and Nuchatlaht). Our population numbers approximately 7,500. Nuu-chah-nulth Tribal Council: www.nuuchahnulth.org/.

"Tom Sayachapis Gives Advice to His Grandson," is from *Tradition and Change on the Northwest Coast* by Ruth Kirk, 46–47.

KWAKWA̱KA̱'WAKW There are approximately 7,500 registered members of the Kwakwa̱ka'wakw First Nations.

The video *Potlatch: A Strict Law Bids Us Dance,* produced by Dennis Wheeler (U'mista Cultural Society, 1975), presents the history of Dan Cranmer's potlatch.

Quotations cited throughout this essay appear courtesy of U'mista Cultural Society, Alert Bay, British Columbia: www.umista.org/.

HEILTSUK The population of the Heiltsuk Nation is approximately 1,200. We represent roughly 70 percent of the people currently living on our traditional lands. The Heiltsuk Nation, Waglisla (Bella Bella), British Columbia: www.heiltsuk.com/.

The description of the early potlatch is from *Physician and Fur Trader,* by William Fraser Tolmie (Vancouver: Mitchell Press, 1963).

For more information on Heiltsuk conservation projects and the Koeye River camp, see the Web sites of the Heiltsuk Nation (above) and the Raincoast Conservation Society: www.raincoast.org/first_nations/koeye.htm.

The story of the first schooner was told to Michael Harkin in 1985–86 by Heiltsuk elder Gordon Reid, Sr. It appears in Harkin's essay "History, Narrative, and Temporality: Examples from the Northwest Coast," in *Ethnohistory* 35:2 (Spring 1988), 99–130.

NUXALK Four major villages make up the Nuxalk Nation: Taliyumc (South Bentinck), Sutslmc (Kimsquit), Kwalhnmc (Kwatna), and Q'umquots (Bella Coola). The old people remember when there were more than 10,000 Nuxalkmc in the Bella Coola Valley alone.

Today our population numbers 1,500 to 2,000. The Nuxalk Nation: www.nuxalk.org/.

The Bella Coola Indians, by Thomas McIlwraith (Toronto: University of Toronto, 1948; reissued in 1992) is the principal source of original research on Nuxalk culture. The Thunder origin story appears on pp. 205–06. The story of the inconsiderate son-in-law appears on p. 416. In the past, it was assumed that the gifts a bride's family received at a wedding were of greater value than those they gave. Whenever a husband gave a potlatch, his wife's relatives were expected to "repurchase" her, although she and her husband remained married.

TSIMSHIAN In 2005, there were 7,587 members of the Tsimshian Nation, belonging to the following bands: Kitselas, Kitsumkalum, Lax Kw'alaams, Metlakatla, Kitkatla, Hartley Bay, and Kitasoo. Tsimshian Tribal Council: www.tsimshian-nation.com/index.html.

More on Tsimshian historical narratives can be found in "Adawx, Spanaxnox, and the Geopolitics of the Tsimshian," by Susan Marsden, *BC Studies* 135 (Autumn 2002); and "Defending the Mouth of the Skeena River: Perspectives on Tsimshian Tlingit Relations," by Susan Marsden, presented in 1996 at the 29th Annual Meeting of the Canadian Archaeological Association in Halifax, available in print through the Museum of Northern British Columbia: www.museumofnorthernbc.com/.

Two classic examples of early twentieth century scholarly writing on the Tsimshian are *Tsimshian Texts,* by Franz Boas, *Bureau of American Ethnology Bulletin* 27 (Washington: Smithsonian Institution, 1902); and Boas's *Tsimshian Mythology, Thirty-first Annual Report of the Bureau of American Ethnology, 1909–10* (Washington: Smithsonian Institution, 1916).

The description of the feast of Nisyaganaat appears in the William Beynon notebooks for 1939, no. 39, in the collections of Columbia University (Ann Arbor: University Microfilms International). Selections from the English texts at Columbia have been published by the Metlakatla Indian Community of Alaska in multiple volumes with the title *Tsimshian Stories.*

NISGA'A The Nisga'a Nation has approximately 5,500 members, most of whom live in four villages along the Nass River—New Aiyansh, Gitwinsilkw, Laxgaltsap, and Gingolx—and in the urban centers Prince Rupert, Terrace, and Vancouver.

The species name for oolichan is *Thaleichthys pacificus.*

Lucy Williams's statement appears in *Nisga'a Origins: In the Beginning, Nisga'a Tribal Council, Ayuukhl Nisga'a Study* 1. (New Aiyansh: Wilp Wilxo'oskwhl Nisga'a Publications, 1984), xii–xiii. The Nisga'a Tribal Council and tribal college—Wilp Wilxo'oskwhl (House of Wisdom)—have produced an excellent series of course materials and references on the land, language, social and economic life, and history of the Nisga'a Nation. Wilp Wilxo'oskwhl: wwni.bc.ca. Nisga'a Lisims: www.nisgaalisims.ca/.

GITXSAN There are approximately 10,000 Gitxsan people worldwide, of whom around 7,000 live on our traditional territories. We make up about 80 percent of the population in this area. Gitxsan Chiefs' Office: www.gitxsan.com/index.htm.

Isaac Danes's narrative was recorded by William Beynon in 1952. See *Medicine Men on the North Pacific Coast,* by Marius Barbeau, *National Museum of Canada Bulletin* 152, Anthropological Series 42 (Ottawa: 1958).

For more on the Medicine Woman of Sickness, see "Tsimshian Shamanic Images," by Marie-Françoise Guédon, in *The Tsimshian: Images of the Past, Views for the Present,* edited by Margaret Seguin (Vancouver: University of British Columbia, 1984), 202-05. Also see *Tangible Visions: Northwest Coast Indian Shamanism and Its Art,* by Allan Wardwell (New York: Monacelli Press, 1995), 71.

Danes's account of becoming a shaman is from Barbeau and Beynon's unpublished notebooks, notes, and correspondence, 1916–54, at the Canadian Centre for Folk-Culture Studies, National Museum of Man, Ottawa, vol. 86. *Potlatch at Gitsegukla: William Beynon's 1945 Field Notebook,* edited by Margaret Anderson and Marjorie Halpin (Vancouver: University of British Columbia Press, 2000), provides a first-hand account of five days of potlatching and pole raising.

For more on the the language Gitxsanimax, see "A Short Practical Dictionary of the Gitksan Language," by Lonnie Hindle and Bruce Rigsby, *Northwest Anthropological Research Notes* 7:1 (1973), 1–60.

For more on our long relationship with our land, see *Tribal Boundaries in the Nass Watershed*, by Neil J. Sterritt, Susan Marsden, Robert Galois, Peter Grant, and Richard Overstall (Vancouver: University of British Columbia Press, 1998).

This essay reflects the knowledge and work of the Book Builders of 'Ksan, an oral history project involving more than ninety contributors, and original research by Heather Harris (on Gitxsan healing traditions), Joanne MacDonald, and Neil Sterritt.

The 'Ksan Museum and Historical Village provides a lively introduction to Gitxsan village life: www.ksan.org/html/village.htm.

HAIDA The gazetted name for Haida Gwaii is "the Queen Charlotte Islands," named by George Dixon in 1787 during a sea otter fur trading expedition to the Northwest Coast.

The Kaigani Haida of Alaska are descended from clans that migrated from Haida Gwaii about 1700.

There are as many dialects of our Haida language as there are ancient villages. The Haida words in this text provide examples of these dialects. *Stl'inll* and *chinaay* are words in the Skidegate dialect; *stlanslaas* and *naanii* are in the Old Massett dialect.

"A Grizzly Bear tried to Kiss and Eagle" can be found in *Northern Haida Songs,* by John Enrico and Wendy Bross Stuart (Lincoln: University of Nebraska, 1996), p. 200. *Haida Songs,* by John R. Swanton, *Publications of the American Ethnological Society* 3 (Leyden: Late E. J. Brill, 1912), describes songs collected during the Jesup North Pacific Expedition of 1909–10. For samples from the recording *Haida: Indian Music of the Pacific Northwest,* recorded and annotated by Ida Halpern (New York: Folkways Records, 1986), see www.folkways.si.edu/search/AlbumDetails.aspx?ID=680.

For more on Haida culture and life, see www.haidanation.ca, www.repatriation.ca, and www.virtualmuseum.ca/Exhibitions/Haida.

TLINGIT The Sealaska Heritage Institute has published a number of books on our land, people, and language. *Because We Cherish You: Sealaska Elders Speak to the Future,* edited by Nora Marks Dauenhauer and Richard Dauenhauer (Juneau: Sealaska, 1981), presents Tlingit oratory from our first Elders Conference, held in Sitka, Alaska. Three volumes—*Haa Shuká, Our Ancestors; Haa Tuwunáagu Yís, For Healing Our Spirit;* and *Haa Kusteeyí, Our Culture: Tlingit Life Stories*—offer an introduction to Tlingit oral history, potlatching, and biography. The institute also hosts a celebration on Tlingit, Haida, and Tsimshian traditions, open to all, in June of every even-numbered year: www.sealaskaheritage.org/.

"Trees in the North Wind" appears in *Life Woven with Song,* by Nora Marks Dauenhauer (Tucson: University of Arizona Press, 2000), 92.

CONTRIBUTORS

LUCILLE BELL *(Haida)* was born into the Tsiits G'itanee Eagle Clan on Haida Gwaii. As heritage officer for the Old Massett Village Council, she has been involved in the repatriation of more than five hundred Haida ancestral remains. Lucille has also curated several exhibitions, including *Haida Spirits of the Sea.*

JANINE BOWECHOP *(Makah)* serves as executive director of the Makah Cultural and Research Center. She is a member of the Washington Governor's Advisory Council for Historic Preservation, vice-chairperson of the National Association for Tribal Historic Preservation Officers, and chairperson of the Makah Tribe's Higher Education Committee.

NIKA COLLISON *(Jisgung, Haida)* of the Ts'aal Eagle Clan, has worked for a number of years to promote Haida language and dance, and to complete the repatriation of Haida remains. A singer, drummer, and weaver, Nika is curator of the Haida Gwaii Museum in Skidegate, British Columbia.

BARB CRANMER *('Namgis from the Kwakwaka'wakw Nation)* lives in Alert Bay, where she continues her work as a documentary filmmaker, community leader, and entrepreneur. Her films about the people and cultures of the North Pacific Coast have been honored by the American Indian Film Festival, Telefilm Canada/TV Northern Canada, the Sundance Film Festival, and the Ontario Arts Council.

JOLENE EDENSHAW *(Haida)* lives in Hydaburg, Alaska, and is committed to the perpetuation of Kaigani Haida culture.

GRACE HANS *(Nuxalk)* is an elder born in Bella Coola. Grace makes dance regalia and is very knowledgeable about Nuxalk ethnobotany. She smokes, dries, and cans salmon to be served in many different ways.

HARVEY L. HUMCHITT, SR. *(Heiltsuk),* is hereditary chief of the Wuyalitxv and a member of the Heiltsuk Hemas (Council of Hereditary Chiefs). A charter boat captain, Harvey has helped lead the effort to preserve and restore the environment of coastal British Columbia and to ensure that economic development in the region includes opportunities for Native people.

CLARENCE JACKSON (*Galtín Asx'áak Daa naawú Tá Gooch, Tlingit*) is of the Ch'áak' (Eagle) Moiety, Tsaagweidí (Killer Whale) Clan. He is an artist, commercial fisherman and charter boat captain, and business-man in Kake, Alaska. Clarence has served in several civic posts, including as a member of the Board of Advisors of Sheldon Jackson College and as a director of the Sealaska Corporation. He is currently a trustee of the Sealaska Heritage Institute.

MARILYN JONES (*Suquamish*) began working for the Suquamish Tribe as an oral historian in the 1980s. She is currently director of the Suquamish Museum on the Port Madison Indian Reservation in Suquamish, Washington.

ROBERT JOSEPH (*Kwakwaka'wakw*) a hereditary chief, writer, and curator, is committed to advancing the interests of Native people within Canada and around the world. He has provided support for former students of Indian residential schools and has worked to improve relationships between aboriginal and non-aboriginal communities and governments.

KI-KE-IN (*Nuu-chah-nulth*) is an artist, writer, and historian living at Emin on the Tl'ikuulth Reserve. The nephew of artist and writer George Clutesi, Ki-ke-in has 40 years' practice as a speaker and ritualist. His essays have appeared in numerous publications, including *In the Shadow of the Sun: Perspectives on Contemporary Native Art*.

MARY JANE LENZ has been a member of NMAI's cultural resources department since the museum's creation in 1989. She was a curator at the Museum of the American Indian/Heye Foundation in New York.

ALVIN MACK (*Nuxalk*) carves in wood and silver. His designs enliven the walls both inside and out at the Acwsalcta School, where he teaches Nuxalk dance. Alvin knows the stories behind the masks.

EVA MACK was born in Scotland and came to Bella Coola in 1968 to teach. She married Harvey Mack and came to share his deep interest in the history of the Nuxalk. She also has a good knowledge of plants and their uses.

HARVEY MACK (*Nuxalk*) is an elder born in Bella Coola. He has a deep interest in Nuxalk culture and history. Harvey carves masks and rattles for use in Nuxalk ceremonies and knows the stories behind the masks.

SUSAN MARSDEN is curator of the Museum of Northern British Columbia, in Prince Rupert. Her scholarly publications include "The Tsimshian, the Hudson's Bay Company, and the Geopolitics of the Northwest Coast Fur Trade, 1787–1840" (with Robert Galois). Her research for the Gitksan Wet'suwet'en Tribal Council in preparation for the seminal land claims case *Delgamuukw v. the Queen* appears in the book *Tribal Boundaries in the Nass Watershed*. Susan married and raised a family in Gitanyow, where she was adopted into the House of Gwin'uu.

LINDSEY MARTIN (Tsimshian) is a member of the Killerwhale Clan of the Gitwilgyoots Tribe of the Tsimshian Nation. She belongs to the House of Gilax'aks. Lindsey was selected for a prestigious internship at the Canadian Museum of Civilization in Ottawa in 1999. She has worked at the Museum of Northern British Columbia since 1998 and is now director of programming. Her responsibilities include creating innovative programming to convey the wealth of history and culture of the Tsimshian Nation. She has devoted her career to learning about her culture and sharing her knowledge with others.

REBEKAH MONETTE (*Makah*) is Makah tribal historic preservation office manager. In that position, she assists the Makah Cultural Research Center with collections management and repatriation, and works within the historic preservation movement to address Native concerns. She lives in Neah Bay with her two sons.

SHIRLEY MULDON (*Lax Goot, Gitxsan*) has been a member of 'Ksan Performing Arts since its inception in 1970 and of the 'Ksan Association since 1989. The daughter of a Gitxsan father and a non-Native mother (the daughter of a Hudson's Bay Company manager), Shirley was adopted into the House of Gitluudahl of the Gisk'aast Clan by her uncle, Moses Morrison. Shirley is married to Earl Muldon, one of the first Gitxsan artists trained at the Kitanmax School of Northwest Coast Indian Art.

ALLISON NYCE (*Nisga'a/Tsimshian*) is from the Gispudwada House of Niistaxhook of Kitselas and the Giskaast House Niisyuus of Laxgalts'ap. She serves as manager of the Ayuukhl Nisga'a (Research) Department of the Nisga'a Lisims Government and as an instructor for Wilp Wilxo'oskwhl Nisga'a (Nisga'a University College) in New Aiyansh. She is completing an M.A. in Anthropology and First Nations Studies at the University of Northern British Columbia.

MEREDITH P. PARKER *(tu tay ah thlub, Makah)* is president of the Board of Trustees of the Makah Cultural and Research Center. She has played an active role in Makah cultural and language preservation through her work at the Ozette Archaeological Project, with the M.C.R.C. language program and photographic archives, and in many other initiatives. Meri also serves the Makah Tribe as chairwoman of the board and chief executive officer of the Makah Forestry Enterprise.

MARIA PARKER PASCUA *(Makah)* works as a specialist in the Makah Language Program at the Makah Cultural and Research Center and teaches Makah language, cultural arts, and basketweaving at Neah Bay High School. Maria also occasionally serves as a cultural consultant for Native American curriculum projects.

LILLIAN SIWALLACE *(Nuxalk)* was born in Bella Coola and lives on the reserve there. She is an elder who speaks and writes Nuxalk, and she taught language in Acwsalcta School and Provincial Schools for quite a few years. Lillian is also a singer and dancer interested in all aspects of Nuxalk culture. She makes dance regalia and cooks traditional foods, such as salmon.

WILLIAM WHITE *(Tsimshian)* holds the name 'Li'amlaxhuu in the House of Ligisgagyoo of the Ganhada Clan of the Gitwilgyoots Tribe of the Tsimshian Nation. Respected internationally as a Tsimshian weaver, William wove the first Raven's Tail and Chilkat robes made in Tsimshian territory since Contact. He travels widely sharing his knowledge with other indigenous people and is a mentor to numerous apprentices across the Northwest Coast. He is dedicated to furthering the world's understanding of the Tsimshian people.

PHOTO CREDITS

NATIONAL MUSEUM OF THE AMERICAN INDIAN OBJECT PHOTOGRAPHY: Ernest Amoroso and Walter Larrimore; supervisory photographer, Cynthia Frankenburg.

2–3, Paul Souders/WorldFoto; 8, Sarah Leen/NGS Image Collection; 18–19, Paul Souders/WorldFoto; 42–43, Flip Nicklin; 66–67, Gary Braasch; 88–89, Lowell Georgia/CORBIS; 110–111, Paul Souders/WorldFoto; 134–135, Paul Nicklen/NGS Image Collection; 140, Canadian Museum of Civilization; 154–155, Kennan Ward/CORBIS; 168–169, Bob Rowan; Progressive Image/CORBIS.

ACKNOWLEDGMENTS

This book and the exhibition of the same title reflect the insights and efforts of many dedicated people who graciously shared their cultural expertise with the authors of these essays. The community curators have asked the museum to thank the following individuals and organizations for their assistance and support:

COAST SALISH Noel Purser, Gene Jones, Sr., Marilyn Wandrey, Gerri "Girly" Joe, Ivy Cheyney, Wayne George, Janis Marquez, Stephanie Alexander, Grace Alexander, Charles Sigo, Leonard Forsman, the Suquamish Tribal Council and Suquamish Tribal Elders, and the Suquamish Tribal Youth Council.

MAKAH Greig Arnold, Polly McCarty, Spencer McCarty, Theron Parker, Crystal Thompson, and Yvonne Wilkie.

NUU-CHAH-NULTH The Nuu-chah-nulth Ha'wiih, who have kindly given permission to place sacred and powerful objects on display. The Nuu-chah-Nulth Tribal Council: Nelson Keitlah, representaive to this project; Shawn Atleo, co-chair, and Nancy Atleo; and Florence Wylie, executive director. Stan Smith.

KWAKWAKA'WAKW The Board of Directors of the U'mista Cultural Society: Bill Cranmer, Stan Hunt, Christine Joseph, Peggy Svanvik, Tyler Cranmer, James Glendale, Basil Ambers, and Andrea Sanborn, Executive Director.

Ethel Alfred, Emma Tamilin, Vera Newman, Donna Cranmer, William Wasden, Jr., Kodi Nelson, Roy Cranmer, Jack Nolie, Lorraine Hunt, Mary Everson, and Wedlidi Speck, who shared their knowledge.

Barb Cranmer's work on this project is dedicated to the memory of Auntie Ethel Alfred and to all Kwakwaka'wakw ancestors.

HEILTSUK The hereditary chiefs of the Heiltsuk Nation.

NUXALK The Nuxalk Heritage Committee, especially Lawrence Mack, Mary Mack, and Della Gascoyne.

TSIMSHIAN Sam Bryant, Matthew Hill, and Bob Hill.

NISGA'A The Nisga'a elders, past and present, who have contributed to the continuing survival of the Nisga'a Nation.

The Nyce family: Harry Nyce, Sr., and Deanna Nyce; Emma

Nyce; Harry Nyce, Jr., and Lori Nyce; Angeline Nyce and Allen Benson; Starnita and Kaitlyn Nyce; James and Suzzanne Wright; and Millicent and Edmond Wright.

GITXSAN Laurel Mould, Executive Director, 'Ksan Historical Village and Museum; Fanny Smith, Neil B. Sterritt, Bill Blackwater, Doreen Jensen, and Brian Muldon.

HAIDA Haida Gwaii Museum at Qay'llnagaay, Skidegate Haida Immersion Project, Skidegate Repatriation & Cultural Committee, Hl Taaxuulang Guud Ad K'aaju, The Haida Heritage and Repatriation Society.

Diane Brown, Guujaaw, Jim Hart, Andy Wilson, Becky Frank, Mary Swanson, Vern Williams.

Our ancestors and all the Haida singers and dancers keeping it alive.

TLINGIT The Board of Trustees, staff, and scholars of the Sealaska Heritage Institute.

The Central Council of the Tlingit and Haida Indian Tribes of Alaska, Edward K. Thomas, president. Harold Jacobs and the late Mark Jacobs, Jr.

The National Museum of the American Indian is indebted to the writers and curators from the eleven Native nations portrayed here for their commitment to this project and for the generous gift of their knowledge. We are also grateful to ROBERT JOSEPH, advisor to the Indian Residential Schools Survivors Society, Vancouver, for his contribution to this book and for guiding the discussions behind the exhibition.

PETER MACNAIR, former curator of anthropology at the Royal British Columbia Museum, and JAY STEWART, former executive director of the Museum at Campbell River, British Columbia, originally conceived of this project, encouraged the communities to take part in it, and graciously assisted the NMAI staff in countless ways. BRUCE BERNSTEIN, NMAI assistant director for cultural resources, helped to get the project under way and keep it on course. In addition to writing on George Gustav Heye and the museum's Northwest Coast collections, MARY JANE LENZ provided curatorial support for both the book and exhibition. Curatorial assistant RACHEL GRIFFIN served as an indispensable link between the communities and the museum staff.

Several people at the museum's George Gustav Heye Center in New York, including JOHN HAWORTH (Cherokee), PETER BRILL, LINDSAY STAMM SHAPIRO, GERALD BREEN, JOHANNA GORELICK, and

SHAWN TERMIN (Oglala Lakota), made important contributions to this project when the Washington staff was consumed with opening the museum on the National Mall. ROSE ALBERTSON and GEOFFREY CAVANAGH did the lion's share of administrative work for the exhibition. Assistant registrar ERIC SATRUM handled the complicated business of bringing loaned and commissioned works to Washington. JILL NORWOOD (Tolowa) vigorously represented the communities' interests within the museum. Collections manager PAT NIETFELD and her staff and the conservation department, led by MARIAN KAMINITZ, worked respectfully and in close consultation with the community curators to prepare the objects selected to be on exhibit.

ERNEST AMOROSO and WALTER LARRIMORE are responsible for the beautiful photographs of the museum's collections that grace this book. Their work was aided by the ingenuity of mount-maker SHELLY UHLIR. ROGER WHITESIDE and supervisory photographer CYNTHIA FRANKENBURG took the wonderful photographs of the communities and community curators on view in the exhibition. LOU STANCARI and SANDRA STARR researched the exhibition's archival photographs.

Project manager BARBARA MOGEL saw *Listening to Our Ancestors* through to completion with determination and tact. KERRY BOYD, assistant director for exhibitions and public spaces, created the handsome exhibition design. MONICA SANJUR produced the graphics. VILMA ORTIZ–SANCHEZ worked to ensure that education was a strength of the project. KAREN FORT served as project manager for the education gallery. Exhibition editor MARK HIRSCH worked faithfully with the community curators to devise the many interlocking exhibition texts. Mellon Fellow and conservator LAUREN CHANG served as institutional memory linking all phases of the project.

HELEN MAYNOR SCHEIRBECK (Lumbee), assistant director for public programs, and her staff, particularly VERNON CHIMEGALREA (Yup'ik), produced the events that complement the exhibition.

TERENCE WINCH, head of publications, conceived of this book and with KEVIN MULROY, senior vice president and publisher of National Geographic Books, oversaw its development. CINDA ROSE created the elegant design of these pages. National Geographic project editor BECKY LESCAZE and production manager GARY COLBERT miraculously found extra days in the calendar. NMAI editor HOLLY STEWART worked diligently to assist the contributors in writing their essays. EMILY MACDOWELL researched the Native quotations that end each chapter. NMAI publications manager ANN KAWASAKI, LAURYN GUTTENPLAN, Smithsonian Office of the General Counsel, and BRUCE FALK, Smithsonian Office of Acquisitions and Contracting, navigated this book through the sometimes heavy seas of the contracting process.

LISTENING TO OUR ANCESTORS

Edited by
Robert Joseph

**PUBLISHED BY
THE NATIONAL GEOGRAPHIC SOCIETY**

John M. Fahey, Jr., President
and Chief Executive Officer
Gilbert M. Grosvenor, Chairman of the Board
Nina D. Hoffman, Executive Vice President

PREPARED BY THE BOOK DIVISION

Kevin Mulroy, Senior Vice President and Publisher
Kristin Hanneman, Illustrations Director
Marianne R. Koszorus, Design Director

STAFF FOR THIS BOOK

Rebecca Lescaze, Project Editor
Cinda Rose, Art Director
Meredith Wilcox, Illustrations Specialist
R. Gary Colbert, Production Director

**MANUFACTURING
AND QUALITY CONTROL**

Christopher A. Liedel, Chief Financial Officer
Phillip L. Schlosser, Managing Director
John T. Dunn, Technical Director
Vincent P. Ryan, Manager
Clifton M. Brown, Manager

NATIONAL GEOGRAPHIC

Founded in 1888, the National Geographic Society is one of the largest nonprofit scientific and educational organizations in the world. It reaches more than 285 million people worldwide each month through its official journal, NATIONAL GEOGRAPHIC, and its four other magazines; the National Geographic Channel; television documentaries; radio programs; films; books; videos and DVDs; maps; and interactive media. National Geographic has funded more than 8,000 scientific research projects and supports an education program combating geographic illiteracy.

For more information, please call 1-800-NGS LINE (647-5463) or write to the following address:

National Geographic Society
1145 17th Street N.W.
Washington, D.C. 20036-4688 U.S.A.

Log on to nationalgeographic.com;
AOL Keyword: NatGeo.

Smithsonian
National Museum of the American Indian

Published in conjunction with the exhibition *Listening to Our Ancestors,* opening January 16, 2006, at the National Museum of the American Indian, Washington, D.C.

Terence Winch, Head of Publications
Holly Stewart, Project Editor

The Smithsonian's National Museum of the American Indian is dedicated to working in collaboration with the indigenous peoples of the Americas to protect and foster Native cultures throughout the Western Hemisphere. The museum's publishing program seeks to augment awareness of Native American beliefs and lifeways, and to educate the public about the history and significance of Native cultures.

For information about the Smithsonian's National Museum of the American Indian, visit the NMAI Website at www.AmericanIndian.si.edu.

Library of Congress Cataloging-in-Publication Data

Listening to our ancestors / National Museum of the American Indian
 p. cm.
 ISBN 0-7922-4190-8
 1. Indians of North America—Material culture—Northwest Coast of North America. 2. Indians of North America—Northwest Coast of North America—Antiquities. 3. Indian philosophy—Northwest Coast of North America. 4. Indian cosmology—Northwest Coast of North America. 5. Northwest Coast of North America—Antiquities. I. National Museum of the American Indian (U.S.) II. National Geographic Society (U.S.) III. Joseph, Robert, 1929- , et al.

E78.N78L58 2005
979.5004'97—dc22

2005051093